IMAGES
of America

BREWING IN
NEW HAMPSHIRE

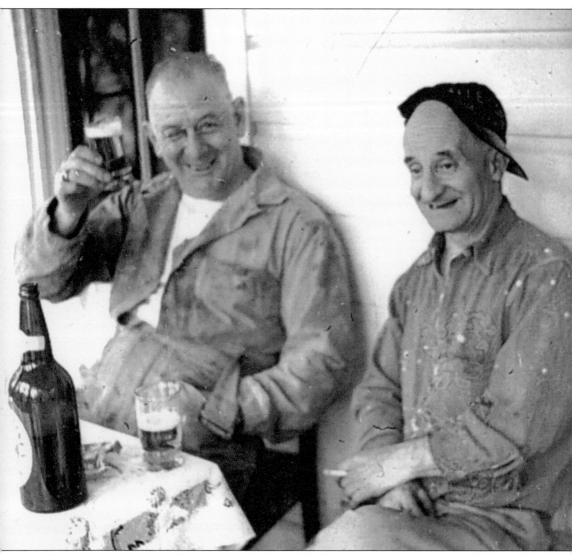

ENJOYING A COLD ONE. Philip Baum (left) and William Baum are enjoying a cold beer after a hard day's work painting. This photograph was taken in the years just after the end of Prohibition. (Courtesy George Baum.)

IMAGES
of America

BREWING IN
NEW HAMPSHIRE

Glenn A. Knoblock and James T. Gunter

ARCADIA
PUBLISHING

Published by Arcadia Publishing
Charleston, South Carolina

Printed in the United States of America

Library of Congress Catalog Card Number: 2004110652

For all general information, contact Arcadia Publishing:
Telephone 843-853-2070
Fax 843-853-0044
E-mail sales@arcadiapublishing.com
For customer service and orders:
Toll-Free 1-888-313-2665

Visit us on the Internet at www.arcadiapublishing.com

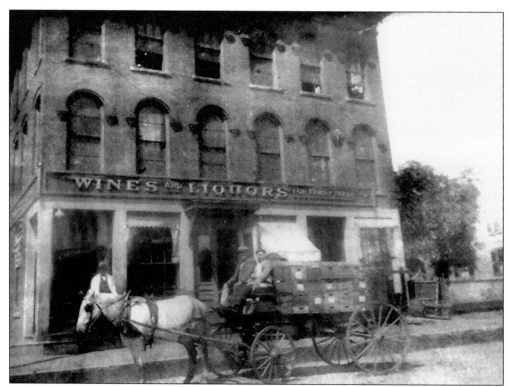

A BEER-DELIVERY WAGON. Scenes like this one were common in city streets before the days of motor power. The photograph, taken in Nashua c. 1900, shows a Bellavance Beverage delivery wagon making its rounds. (Courtesy the Bellavance family.)

CONTENTS

ACKNOWLEDGMENTS

We would like to thank all of those individuals who have given us help and guidance during the course of writing this book. Especially helpful were Rus Hammer, who gave us complete access to his outstanding brewery memorabilia collection; Nicole Cloutier at the Portsmouth Public Library; reference librarians Christine Burchstead, Holly Johnson, and Samantha Maskell at the Rockingham Free Public Library (Vermont); George Poulin and Eric Momsen of the Somersworth Historical Society; Dick LaBonte; Deb Runnals; Virginia Putnam at the Walpole Historical Society; Joe Bellavance for access to his family archives; David Smolen, special collections director at the New Hampshire Historical Society; brewers Peter Egelston, Greg Blanchard, Tod Mott, Mike Luparello, Will Gilson, Kirsten Neves, Nik Stanchu, and marketing manager Ethan Stienstra for taking time out of their schedules to give personally guided tours of their breweries; and to Suzanne Guiod and the folks at Arcadia for their enthusiastic response to our project.

On a more personal note, we would both like to thank our families for their support. From Glenn: Terry, I cannot thank you enough for your support for the last 23 years. You have always been my biggest fan. From Jim: I would like to thank my wife, Kathy, for her encouragement, my family for listening to me talk constantly about beer, and to my friend Tom Chrane for his influence (and beer) over the years.

In addition to city directories, local land records, and town histories, the following published works have been consulted: *Brewed in America: The History of Beer and Ale in America* (1962), by Stanley Baron, and *Frank Jones: King of the Alemakers* (1976), by Ray Brighton.

The authors hope that you will now sit back and relax, maybe with a New Hampshire brew on hand, and enjoy the book. However, we remind our readers to always drink responsibly and to never drink and drive.

Authors' note: The reader may wonder why vintage photographs are not presented in this work for all of New Hampshire's old breweries. The answer is quite simple; with the exception of the Frank Jones Brewery, few photographs for these breweries are known to exist. For the most part, they were considered a workaday part of everyday life, just as the gas station is today, and were seldom photographed. Thus, the authors have had to rely on hard-to-find period advertisements and rare physical artifacts to augment what photographs have survived to tell the brewing history of New Hampshire. In an effort to tell the story of brewing today, all of the state's breweries and brewpubs were contacted. With the notable exception of Anheuser-Busch, most responded with photographs and information about their operations.

INTRODUCTION

The history of beer and its brewing in New Hampshire is almost as old as its settlement by English colonists in 1623. At this time, beer was the universal beverage of Englishman and not just due to matters of taste. At a time when sanitary conditions in England were less than ideal, water was often unfit for drinking. It is very likely that just as in Jamestown, Virginia, in 1607, beer was in short supply during New Hampshire's earliest Colonial days, forcing the colonists to drink water. Soon enough, however, this hardship was overcome when the colonists became settled, and the ingredients and means were found to brew beer and ale. Beer for the consumption of the early colonists was likely first brewed in quantity at Capt. John Mason's Great House at Strawbery Banke, for in 1635 an inventory of his stores there included 15 barrels of malt. From then on, beer was brewed in New Hampshire, in one form or another, on a continuous basis well into the 20th century.

Before continuing this account, we should take a brief moment to define beer and the various forms in which it was first brewed. At its most basic level, "beer is the product of fermentation of an infusion of cereal malt," and its production can be thought of as "a form of cooking." The type of beer is determined by the ingredients it contains. In the early days, beer contained hops, while its cousin ale did not. This held true until the 17th century. Beer brewed using hops was not as strong as ale but had a longer shelf life. Because hops and the normal ingredients to make beer and ale were often totally lacking, or in extremely short supply, the colonists often had to resort to alternative ingredients more readily found. Spruce beer, also called "homo," was brewed using the tips of their boughs in place of hops for both flavoring and preservation. One recipe for this variant called for 20 gallons of maple syrup and a half peck of new growth black spruce tips. Many other unusual ingredients were also used, including beer made from molasses, bran, or maize (corn). The same was true of ale, one common variant being pumpkin ale. Though it may seem unusual to the casual beer drinker of today, the modern-day crafting of beers and ales using such ingredients as blueberries, pumpkins, cherries, and the like is really a throwback to Colonial times when such ingredients were resorted to out of necessity. Beer was brewed in a variety of strengths in earlier times. Small beer was the weakest beer in terms of alcoholic strength and was meant to be consumed immediately after brewing. Strong beer and ship's beer were higher in alcoholic content and kept longer. Other variants of these types of beer include tonic beer and champaigne beer, both of which were touted for their medicinal value.

While beer has been a constant in the everyday life of New Hampshire since its first settlement, its production in the early days is not well documented. This is not surprising, as beer and ale that was produced on the homestead for family consumption was seldom commented upon, and recipes for such were preserved by oral tradition and seldom written down. However, there

can be no doubt that the first commercially brewed beer was that served at local taverns. One documented example is Samuel Wentworth, who lived in New Castle from 1669 to 1678 and kept a tavern, "having libertie to entertain strangers and to sell and brew beare at the sign of ye dolphin." Among the many individuals who are listed in early records as tavern keepers and were probably engaged in brewing on a small scale were Henry Sherburne (Portsmouth), who was granted a tavern license in 1642; his nephew Henry Sherburne (Portsmouth), who owned the Glebe Tavern at the Plains c. 1700; John Johnson (Greenland), who was a tavern keeper for many years beginning c. 1673; Richard Welcom (Isles of Shoals) from 1681 to 1686; and Francis Messer (Portsmouth), who ran an alehouse from 1683 to 1686. Two of the earliest inn holders in New Hampshire, curiously enough, are listed as vintners. They were Walter Abbott of Portsmouth (1645) and Robert Tuck of Hampton (1638). While both were winemakers by trade, it is highly likely that they also brewed their own beer. In regards to commercial enterprise, the earliest known brewer so far discovered is John Webster of Strawbery Banke (Portsmouth). He was licensed to sell wine in 1649 and licensed to sell beer at the Isles of Shoals in 1651. In 1651, he deeded all his land and dwellings, including a brew house, to his son John. Thereafter, he operated a public house from 1656 to 1661. John Jr. continued to operate a public house (and likely brewed beer) after his father's death in 1662, but he was apparently unsuccessful. For reasons unknown, he was ordered to take his sign down in 1668. Not to be forgotten is the role that women played in the brewing business. They also operated taverns, usually as widows, and probably brewed beer for their customers just like male tavern keepers did. A few such examples are Gertrude Messer (Portsmouth, 1693), and Rachel, the widow of brewer John Webster, who operated a public house that was rather unruly in the 1670s. Eleanor, the widow of William Urin, was licensed to sell liquor at the Isles of Shoals in 1677. Later, as the widow of tavern keeper Richard Welcom, she operated a tavern there from 1692 to 1695. Later on, in the 19th century, Mrs. Henry Evans of Dover advertised the only commercial brewery known to have been operated by a woman.

From this early beginning down to the days of Frank Jones's empire, Portsmouth remained the state's brewing capital. However, important breweries were established in other parts of the state as its population grew, and the brewing history of New Hampshire as a whole is an interesting and unique example of industrial expansion in the 19th century.

One

THE EARLY DAYS

In New Hampshire's early days of brewing, tavern keepers produced the majority of the beer brewed in the state. The identity of the first person to brew beer without operating a tavern is unknown. One candidate is William Pottle Jr. of Stratham. He was a well-known brewer who supplied his product to both the Bell Tavern and the Earl of Halifax Tavern of Portsmouth. Prior to the American Revolution, he was branded a Tory when he was heard to say that he would join General Gage of England in fighting against his country. In December 1774, fellow townsman Deacon Stephen Boardman publicly confronted Pottle in Portsmouth and incited a riot by exclaiming, "I think that this man has conducted in such a manner that we ought not to buy any of his malt—for my part I am determined I will not: I should not choose to drink beer made of Tory malt." Boardman later stated, "Not that I had any objection to his malt as not good in itself: but because I thought we ought . . . have nothing to do with men of that character."

Other early brewers in the state include Scotsman Robert Trail, who was a prominent merchant and comptroller for the port of Portsmouth in the 1770s, and Michael Martin, who produced a first-rate brew in Portsmouth sometime between 1810 and 1820. Evidently Martin's brewing did not pay off. He later resorted to a life of crime and was hanged as a highwayman in Massachusetts in the early 1820s.

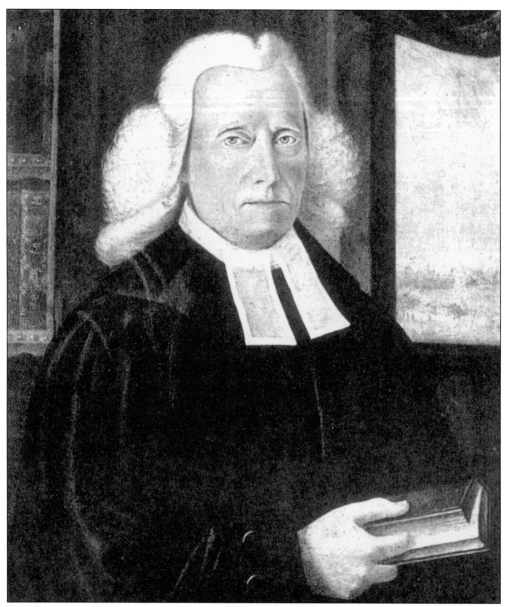

THE REVEREND SAMUEL HAVEN. Reverend Haven may rightfully be called the patron saint of brewing in New Hampshire. Born in 1727 in Framingham, Massachusetts, he attended Harvard and graduated in 1749. He accepted a call to preach at Portsmouth's South Church in 1752, and he remained in the city until his death in 1806. He was one of the most popular preachers of his day and was "intimate and familiar with even the poorest members of his congregation." Because of this intimacy, there can be no doubt that Haven not only was served beer or ale on many of his parish visits, but that he also witnessed the destructive effects of stronger drink, such as rum and whiskey, on his flock. Perhaps because of this, he proposed in 1789 that the Piscataqua Association of Ministers sponsor a brewery so that beer might take the place of "more ardent spirits." Unfortunately, his motion was dismissed, and it was not until the middle of the next century that any substantial commercial brewery was established in Portsmouth. (Courtesy the Massachusetts Historical Society and the Portsmouth Public Library.)

GEORGE WASHINGTON'S BEER RECIPE. The father of our country was an avid beer and ale drinker even as a young man. This recipe for small beer, probably undrinkable by today's standards, was recorded by him in a 1757 notebook. While there is no record of what brew he drank when he visited New Hampshire in 1788, it is interesting to note that his private secretary, Portsmouth native Tobias Lear, counted the procurement of "the best Porter in Philadelphia" as one of his many duties after Washington became president. This is a transcription of the original, without spelling or grammar changes: "Take a large Sifter full of Bran / Hops to your taste—Boil these / 3 hours. Then strain out 30 Gall. / Into a Cooler put in 3 Gallons / Molasses while the Beer is / Scalding hot or rather drain the / Molasses into the Cooler. Strain / The Beer on it while boiling hot / Let this stand til it is little more / Than Blood warm. Then put in / A quart of Yeast if the weather is / Very cold cover it with a Blanket. / Let it work in the Cooler 24 hours / then put it into the Cask. leave / the Bung open til it is almost done / working—Bottle it that day Which / it was Brewed." (Courtesy the New York Public Library.)

Portsmouth Bell Tavern, Congress-Street.

THE subscriber informs his friends and the public, that he has taken that central and commodious HOUSE, lately occupied by Mr. *Greenleaf*, as the BELL TAVERN; and has opened a Public House for the reception and accommodation of Ladies and Gentlemen, Travellers and others. He flatters himself he shall be able to entertain his guests in an agreeable manner; his table will be supplied with the best the season and market affords— his Liquors of every kind are pure and genuine—his Stable shall be well attended, and furnished with the best hay and provinder, and his ambition ever will be to please all those who may favour him with their commands.

SETH WALKER.

Portsmouth, Oct. 19.

A BELL TAVERN ADVERTISEMENT, 1802. This advertisement, dated October 19, 1802, appeared in Portsmouth's *Republican Ledger*. Typical for its time, the Bell Tavern offered agreeable entertainment and drink of all kinds for both weary travelers and local residents. Indeed, establishments of this type served as a gathering place for locals to discuss current events and the hot topics of the day while quenching their thirst with a tankard of ale.

STOODLEY'S TAVERN, PORTSMOUTH. Built *c.* 1761 by Col. James Stoodley, this well-known tavern was one of Portsmouth's most fashionable establishments. It was a favored spot for those making the journey between Maine and Boston, while its upper floor was used for both Masonic functions and public dancing balls. (From C. S. Gurney's *Portsmouth Historic and Picturesque*, 1902; courtesy the Portsmouth Public Library.)

PETER SLEEPER'S TAVERN, BRISTOL. Giant signs, such as this one measuring over four feet high and three feet wide, were used to attract travelers to stop for entertainment, food, and drink. Sleeper's Tavern was a popular gathering place, and it is likely given the town's remote (for the time) northern location, that Sleeper brewed his own beer or ale for his customers. (From Richard Musgrove's *History of Bristol*, 1904.)

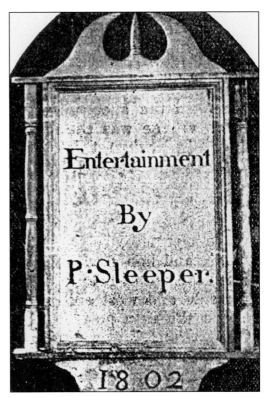

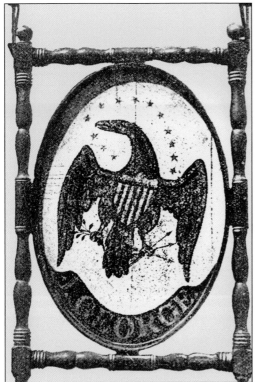

THE JOHN GEORGE TAVERN. The Eagle Hotel in Concord was originally established as a tavern in 1814 by John George. The hotel eventually took its name from the distinctive sign that hung outside, and was a local landmark for nearly 30 years. (From J. O. Lyford's *History of Concord*, 1903.)

THE BENJAMIN WIGGINS TAVERN. Stratham native Benjamin Wiggins was among the first tavern keepers in Hopkinton beginning in 1786. Not only did he probably brew his own beer, but he was also justice of the peace, postmaster, and merchant. In taverns like this all across the state, many important affairs were conducted with tankards of beer or ale close at hand. (From C. C. Lord's *Life and Times in Hopkinton*, 1890.)

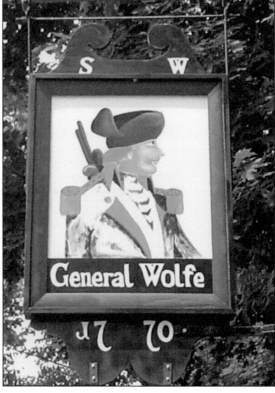

THE GENERAL WOLFE TAVERN, ROCHESTER. This tavern, one of many to bear the name of this British hero, was operated by Stephen Wentworth as the only tavern in town. It was also a store where beer, rum, and crockery could be bought. Royal Governor Wentworth was a frequent visitor, and in the early days of the Revolution after the battles of Lexington and Concord, it served as a recruiting office. (Courtesy Roseann Benoit.)

14

THE SAMUEL WENTWORTH TAVERN, C. 1669. From 1669 to 1678, Samuel Wentworth kept a tavern in New Castle, being licensed to "entertain strangers and to sell and brew beare [*sic*] at the sign of ye Dolphin." (From John Albee's *New Castle Historic and Picturesque*, 1885.)

A WOODEN TANKARD. Wooden drinking vessels such as this one were the most common to be found in Colonial New Hampshire. Men often carried their own tankards with them to the local tavern. However, in larger towns, such tankards were usually supplied by the tavern keeper and, in later days, were made of pewter. (From Alice Morse Earle's *Home Life in Colonial Days*, 1898.)

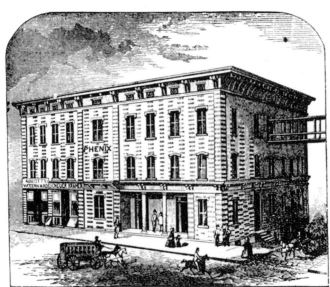

PHENIX HOTEL,

Main Street, Concord, N.H

L. LITTLEHALE, Proprietor.

THE PHENIX HOTEL, CONCORD. This famous hotel, pictured here in an 1867–1868 city directory, was a landmark in the city of Concord. Surrounding this area, no doubt attracted by the many travelers passing through, were drinking establishments such as George Adams's alehouse.

TO BE SOLD BY

John Bodge,

AT HIS HOUSE IN DANIEL STREET,

EXCELlent ſtrong BEER, by the Barrel, or Gallon, or leſs Quantity. Portſmouth. Feb. 28.

A JOHN BODGE ADVERTISEMENT, 1801. Before the era of commercial breweries, beer was often produced at home and offered to the public. Capt. John Bodge placed this advertisement in Portsmouth's *Oracle of the Day* on February 28, 1801, for a strong beer that he likely brewed himself. This was not the only commodity Bodge sold, for he later sold sperm oil from his shop. (Courtesy the Portsmouth Public Library.)

HOPS.

A SUPPLY of HOPS juſt received and fo
ſale by ROBERT FOSTER,
Penhallow ſtreet, July 4.

A HOPS ADVERTISEMENT, 1815. Hops are a key ingredient for brewing beer and were often hard to come by in New Hampshire since they were not locally grown. This advertisement from the *New Hampshire Gazette* indicates that hops were imported, either from overseas or the state of New York, on an occasional basis. Late in the 19th century, hops were also grown extensively in the Pacific Northwest. (Courtesy the Portsmouth Public Library.)

LAIRD'S YEAST
For Rising Bread, &c.

THE above article may be had of the subscri
ber, fresh from the *Brewery* every week.
LAIRD's STRONG BEER and PORTER
wholesale and retail—For sale by
JOHN G. TILTON,
Dec. 26. *No. 4, Main-Street.*

A YEAST ADVERTISEMENT, 1827. This advertisement appeared in a Dover newspaper on January 30, 1827, and denotes another key component in the brewing process. The location of the supply for this yeast, Laird's Brewery, is unknown. However, it was likely outside New Hampshire, perhaps Massachusetts, as the yeast was advertised for sale on a weekly, not daily, basis. (Courtesy the Dover Public Library.)

A STRONG BEER ADVERTISEMENT, 1828. The fact that Dover's Mark Noble imported such a large quantity of strong beer is an indicator that no commercial breweries in the region were yet established as of May 1828. It was nearly another 30 years before any New Hampshire town saw the establishment of such enterprises. (Courtesy the Dover Public Library.)

A MICHAEL PROUT ADVERTISEMENT, 1858. Prout was an early brewer in the city of Manchester. After brewing on his own for one year from 1856 to 1857, Prout later acted as a distributor for the well-known Albany Ales from New York, as well as for the ale made by Portsmouth brewer John Swindell. This advertisement appeared in an 1858 city directory.

Champaigne

OR SMALL

BEER.

☞—**This valuable article has long been**
ught for and lately discovered; it being the richest and most nourishing drink
er offered. Prepared by

CHARLES C. HODGDON, Concord, N. H.

Opposite the American HOTEL.

Although many have sought to find out the *invention of this* BEER, they have never been able t
cover its genuine origin, nor cannot, unless Certificates be given By its author, C. C. HODGDON
I shall keep at all times, through the Summer Season the same kind of BEER, at My Shop, oppd
the AMERICAN HOUSE ; or otherwise in a Cart, which will pass frequently through the Street

The SUBSCRIBERS are acquainted with the COMPOSITION and the manner of making the

CHAMPAIGNE BEER,

d consider it the most inoffensive of any BEER in common use. It contains no active or deleteriou
redient, and those who use it will find a valuable substitute for Cider, Porter, Mead, Strong Beer, &
ll seasons of the year.

<div align="right">

Doct. PETER RENTON,
Doct. THOMAS BROWN,
Doct. TILTON ELKINS, ,.

</div>

CONDORD, N. H. June 1st, 1836. .

<div align="right">

SAMUEL WEBSTER, PRINTER.

</div>

A CHAMPAIGNE BEER BROADSIDE, 1836. Champaigne beer was low in alcohol content, as
denoted by its alternative name small beer, and was primarily sold for its healthful benefits.
This broadside touts not only the brew's "nourishing" aspects, but with the doctor's names in
the lower right, it seems also to promote its consumption for medical purposes. Note that this
beer was sold not only at the American Hotel but also on a cart that passed through the streets
of town. (Courtesy the New Hampshire Historical Society.)

W. I. RUM.

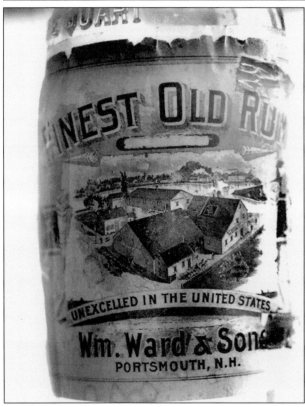

93 Hhds. pure W. I. RUM, just landed from schooner Betsy, and for Sale by **B. H. PALMER,** *No. 7, Main-street, Dover,* or **THEODORE SHEAFE,** *at Jacob Sheafe's Wharf, Portsmouth.*

May 6.

PORTSMOUTH RUM. While beer was originally the beverage of choice in New Hampshire and New England, rum from the West Indies and that distilled locally soon became a more popular drink. Because of Portsmouth's maritime trade with the West Indies, rum was readily available and inexpensive. Above is a newspaper advertisement from an 1828 Dover newspaper advertising rum that had just landed. Later, rum distilleries were found in almost every large town, and Portsmouth was no exception. To the left is a label for a brand of rum distilled in Portsmouth by William Ward *c.* 1870. (Above, courtesy the Dover Public Library; left, courtesy Rus Hammer.)

PORTSMOUTH WHISKEY. Beer's other competitor was that old demon drink, whiskey. Because this powerful drink could be made with ingredients that were readily available in New England, it too was a popular drink among the working class. Not only was it cheap, but it could get one intoxicated rather quickly. In contrast, the elite in New Hampshire society, in addition to beer and ale, usually resorted to more upscale alcoholic beverages like Madeira wine. The photograph to the right shows the whiskey brand of distiller William Ward of Portsmouth, c. 1870. Note the harbor scene of Portsmouth and the black revenue sticker on the label. Below is a later version of this popularly named whiskey, c. 1907, bottled in Portsmouth but distilled outside of New Hampshire. (Right and below, courtesy Rus Hammer.)

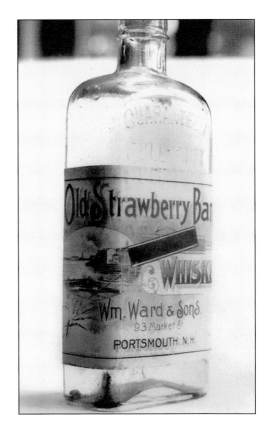

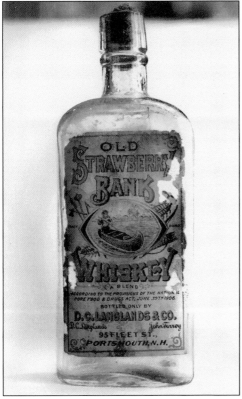

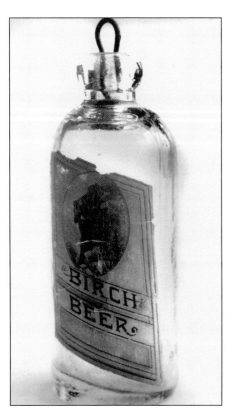

A BIRCH BEER BOTTLE. In addition to regular beer, beers were also brewed that were appealing to the many local temperance groups forming to fight for Prohibition. One such type was the old-fashioned birch beer, which was one of the first types of soda ever made. This bottle, featuring the Old Man of the Mountain, dates from *c.* 1900 and was bottled in Concord. (Courtesy Rus Hammer.)

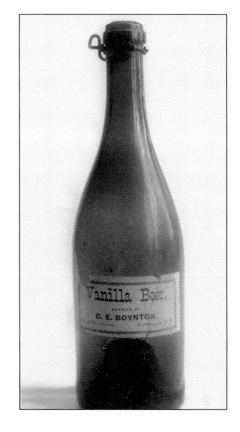

A VANILLA BEER BOTTLE. This vanilla beer was bottled by the Boynton Company of Portsmouth *c.* 1880. It is unknown if this was a beer variety that contained alcohol, but such is unlikely. It was probably an early version of what we call cream soda today. (Courtesy Rus Hammer.)

THE RIVERIOUS BURT BREWERY, MANCHESTER. Almost nothing is known about this commercial brewery, which may be the state's oldest. Burt advertised in the city directory for 1854 and disappeared afterward. Note the emphasis by Burt for his ale's "family use," which was not uncommon. During this time, beer and ale, despite their alcoholic content, were considered suitable for all members of the family to drink, children included.

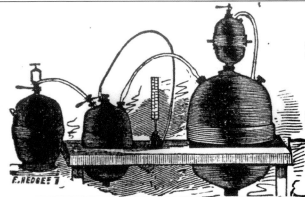

F. L. GRAY, MANCHESTER. Gray operated from approximately 1866 to 1881. Though his sarsaparilla beer was more akin to a soda beverage than real beer, he was also a dealer in ale and porter. This advertisement, dated 1873, appeared in the city directory and is interesting in its depiction of the carbon dioxide tank system for charging soda fountains. Years later, carbon dioxide was, and still is, used in the process for bottling beer.

DANIEL FORD,

Manufacturer of

Smith's White Root & Hop Beer.

BOTTLER AND DEALER IN

Bottled Cider, Ale, Porter, Lager Beer, & Mineral Water

No. 4 Henderson's Block,

FRANKLIN SQUARE, DOVER, N. H.

DANIEL FORD,

MANUFACTURER OF

SMITH'S WHITE ROOT

AND HOP BEER.

DEALER IN

BOTTLED CIDER, ALE, PORTER,

LAGER BEER, MINERAL WATER

ALSO DOWN'S GENUINE

BELFAST GINGER ALE.

NO. 4 HENDERSON'S BLOCK,

Franklin Square, Dover, N. H

Parties and Picnics supplied at short notice and reasonable rates.

DANIEL FORD, DOVER. Though Daniel Ford was an established distributor in Dover, he also produced his own brew, which he termed hop beer after its main ingredient. The advertisement above appeared in the city directories for 1870 and 1871, while the advertisement to the left appeared in *Foster's Daily Democrat* in 1873. (Courtesy the Dover Public Library.)

AN IRA DANIELS ADVERTISEMENT, 1883. Daniels operated a brewery and also manufactured a variety of sodas in Great Falls (Somersworth). This advertisement appeared in the Dover–Great Falls directory and is the only known advertisement for this small brewery, which operated c. 1870–1884. What became of Daniels after 1884 is uncertain, but he may have moved to Charlestown, Massachusetts. (Courtesy the Dover Public Library.)

IRA T. DANIELS & CO.,

MANUFACTURERS OF

TONIC, CREAM, LEMON, GINGER, BIRCH, PINE-AP-PLE, RASPBERRY, STRAWBERRY, XLCR AND SASSAPARILLA BEER, AND GINGER ALE.

BOTTLED ALE, CIDER AND LAGER BEER

CONSTANTLY ON HAND.

ALE AND LAGER BY THE CASK.

Orders left at Manufactory, corner of

GREEN and WASHINGTON STREETS, GREAT FALLS, N. H.

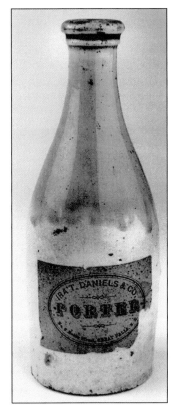

AN IRA DANIELS BOTTLE. This stoneware bottle is one of only several such bottles in existence, and they are the only surviving artifacts of Daniels's brewery. It dates from c. 1870, when Daniels brewed at his residence on Noble Street. Later, he established a manufactory at the corner of Green and Washington Streets. There is no doubt that Daniels found many customers from those employed at the several Great Falls mills. (Courtesy Rus Hammer.)

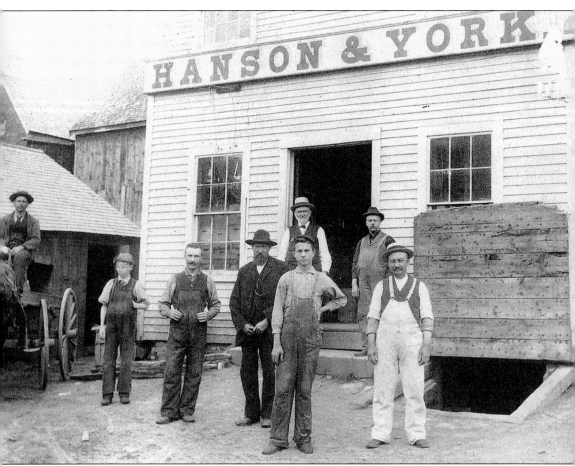

HANSON AND YORK, SOMERSWORTH. The partnership of Hanson and York in Somersworth (Great Falls) was the successor to Ira Daniels's brewery and occupied the same location, and probably the same building, at the corner of Green and Washington Streets. Little is known about their operation, and there are no records or artifacts that show whether they brewed beer or just acted as bottlers and distributors. Barely visible on the Hanson and York sign on the right is a picture of a cask. Note the huge cellar door that led to the building's basement, where casks of beer and other beverages were stored prior to being sold. (Courtesy the Somersworth Historical Society Museum.)

HENRY EVANS,

STOCK, PALE, AND AMBER ALE

BREWER,

COCHECO BREWERY, . . . DOVER, N.H

PERSONAL ATTENTION GIVEN TO ALL ORDERS.

THE COCHECO BREWERY, DOVER. Henry Evans came to Dover from Somersworth *c.* 1864 and soon thereafter established the city's first commercial brewery on Rollinsford Road, opposite what is now New York Street. Evans purchased the land from William Lyman in 1864. The advertisement seen above appeared in the city directory for 1867. Henry Evans died in 1869, leaving behind his wife, Martha, and children Henry Jr., Martha, John, and Ann. Surprisingly, Martha Evans continued to operate her husband's brewery, adding the title of Mrs. to its name, as indicated in the directory advertisement below, dated 1869. How long the brewery operated is uncertain, but it was likely for only a year. By 1871, Martha was remarried to a man with the last name of Esher, and the Evans brewery was no more. (Courtesy the Dover Public Library.)

Mrs. Henry Evans,

STOCK, PALE, AND AMBER ALE

BREWER,

Cocheco Brewery, Dover, N. H.

Careful attention given to all Orders.

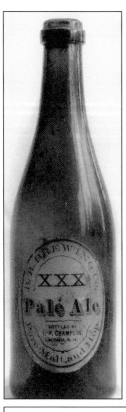

The B. B. Brewing Company. The bottle for this brew, which sports the traditional XXX designation for ale, poses a historical mystery. While the ale was bottled by the well-known John Champlin of Laconia *c.* 1875, whether or not the B. B. Brewing Company was located in New Hampshire is unknown. The bottle itself is a rare piece of brewing history, as few are known to exist. (Courtesy Rus Hammer.)

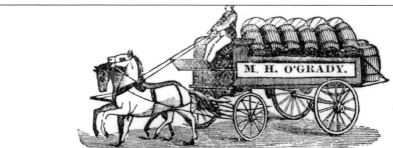

M. H. O'GRADY

MANUFACTURER OF

SODA AND MINERAL WATERS,

GINGER ALE, TONIC BEER, ETC.,

BOTTLERS OF ALE, LAGER BEER, PORTER AND CIDER

A Michael O'Grady Advertisement, Nashua. This appealing advertisement, which appeared in the city directory for 1884, depicts the typical brewery delivery wagon of the day fully loaded with casks. O'Grady operated in Nashua for many years, primarily as a bottler and distributor. That he did some brewing is evidenced by his production of tonic beer, which was likely a form of low-alcohol small or champaigne beer.

Two

HOW BEER WAS MADE

The brewing of beer and ale prior to the steam age was accomplished with surprisingly simple equipment. A wooden barrel was used as a mash tub, where the malt was ground up (mashed) and mixed with water. The resulting product was then boiled, either in a wooden vat or a simple metal boiler. Following this, the mixture, called wort, was strained and transferred to a wooden fermentation tub, where yeast was introduced into the mix. This part of the process, where yeast interacted with the sugar in the malt to form alcohol and carbon dioxide, was crucial but little understood by brewers of yesteryear. With little knowledge of chemistry and the true properties of yeast, the brewing process was often hit or miss. Experience and a cook's instinct were usually the hallmark of a good brewer. Beer for commercial consumption was usually brewed in a building called a brew house. The earliest known brew houses in the state were those of John Webster and one established in 1652 near Dover Point (possibly in operation as early as 1640).

With the introduction of steam power in the 1850s, followed by the utilization of the newly developed pasteurization process in the 1870s, the brewing of beer on an increasingly larger scale became possible, and breweries as we know them today were quickly established. These photographs show how beer was manufactured from start to finish at the Frank Jones Brewery *c.* 1901.

THE FRANK JONES WATERWORKS. As water was the main ingredient in beer, Frank Jones would not use just any water for his beer. In the beginning, he used water from the town municipal system. Instead of continually paying for it, he had a well dug on the brewery's property. This allowed him to sell excess water to the town. (Courtesy Rus Hammer.)

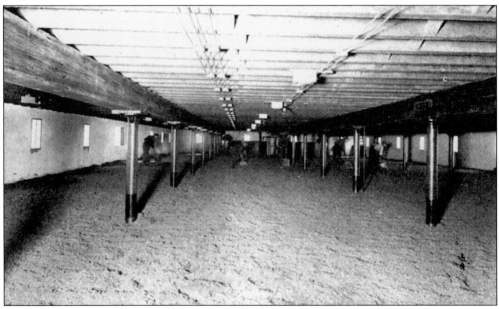

THE MALTING ROOM. Since grain is a dormant seed, it needs to go through a process called malting to create starches. During malting, the grain is spread out, water is sprayed on it, and it is allowed to grow. To keep it from rotting in Colonial times, the grain needed to be turned by hand with coal shovels. After it had germinated, it was dried and used for making beer. (Courtesy Rus Hammer.)

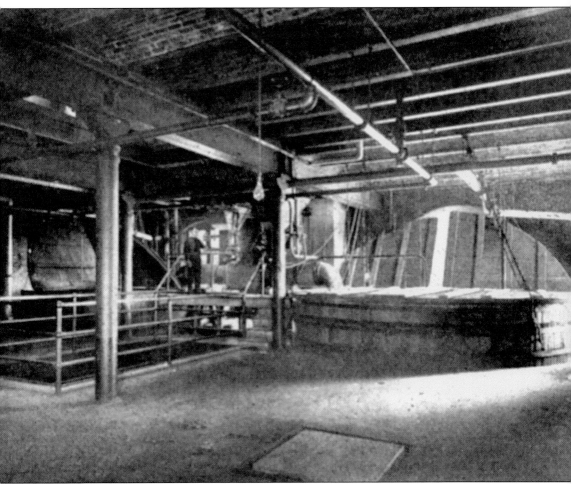

THE MASH TUN. The mash tun was originally just a giant wooden vat. It was made no different than the wooden kegs in which the final product was stored. The vat was recessed into the floor for insulation and ease of operating. This giant vat was where the malted barley was mixed with hot water at a temperature between 150 and 160 degrees. The hot water caused the starches to break down and become sugar. After the sweet liquid was separated from the spent grain it was called malt extract. This extract was pumped to another container to make the beer. (Courtesy Rus Hammer.)

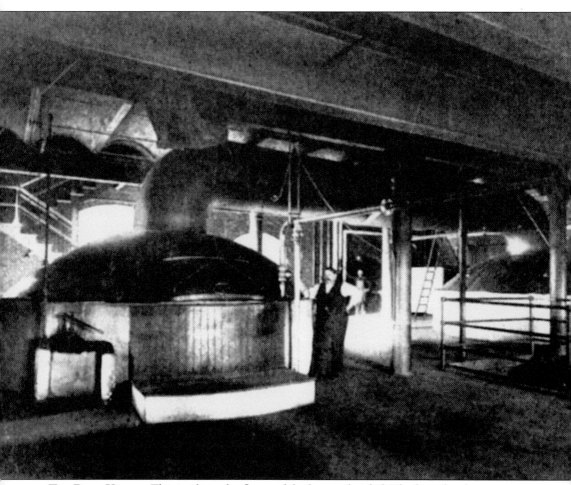

THE BREW KETTLE. This is where the flavor of the beer is decided. The brew kettle was a copper tank that the malt extract and hops were boiled in. After the mixture was boiled it was referred to as wort. Although all steps prior to this point were critical in the production of beer, if the wrong proportion of hops and extract was mixed, the end product would be undrinkable. The man in the picture is more than likely the master brewer. This person was held higher than the owner of the company. He alone controlled the flavor of the beer. With this amount of control, he was able to re-create the same flavors over and over again. (Courtesy Rus Hammer.)

HOW THE WORT WAS COOLED. The wort needs to be cooled before it goes to the fermentation tank. All of the boiling wort was pumped through these pipes. The pipes acted like a radiator to remove the heat from the liquid. The liquid needs to be cooled so yeast could be added. If the wort was too hot, the yeast would die, and no alcohol would be produced. (Courtesy Rus Hammer.)

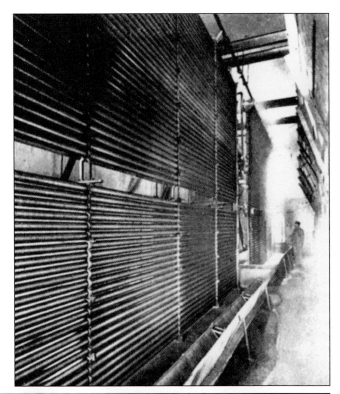

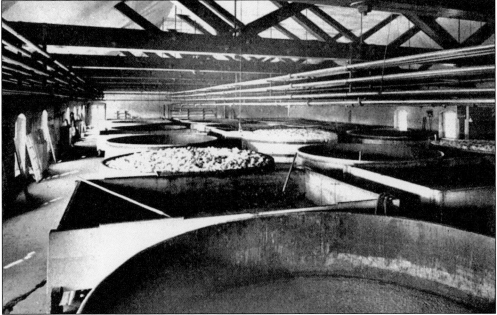

THE FERMENTATION HOUSE. The fermentation tanks were copper-clad vats. This type of fermentation was referred to as open fermentation. It is at this point that yeast is added. The alcohol the yeast produces keeps bacteria from spoiling the batch. The white fluffy stuff in the vat is foam. As the yeast eats the sugar, carbon dioxide is produced and the carbon dioxide bubbles cause foam. (Courtesy Rus Hammer.)

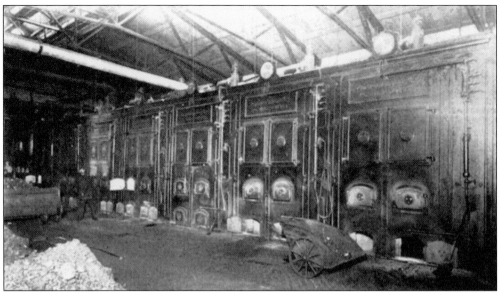

STOKING THE FIRES. Consider the amount of energy needed to run the brewery. These boilers were needed to generate steam to boil the wort, run generators, and drive pumps. They were coal fired and were maintained by hand. They were probably run 24 hours a day, 7 days a week. It was a hot job, even in the winter. (Courtesy Rus Hammer.)

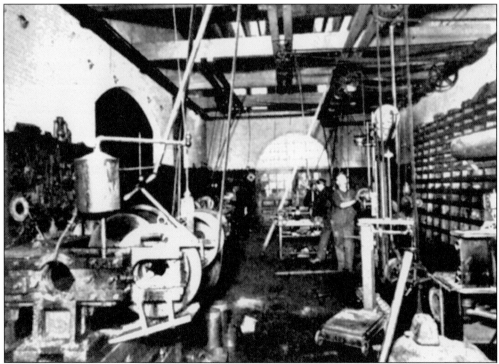

THE MACHINE SHOP. At the beginning of the 20th century, mass production was in its infancy. If something in the brewery was damaged or broken, it was probably not a part that could be ordered, but rather needed to be made in a shop. It was a necessity to have a machine shop on-site to keep the beer flowing. (Courtesy Rus Hammer.)

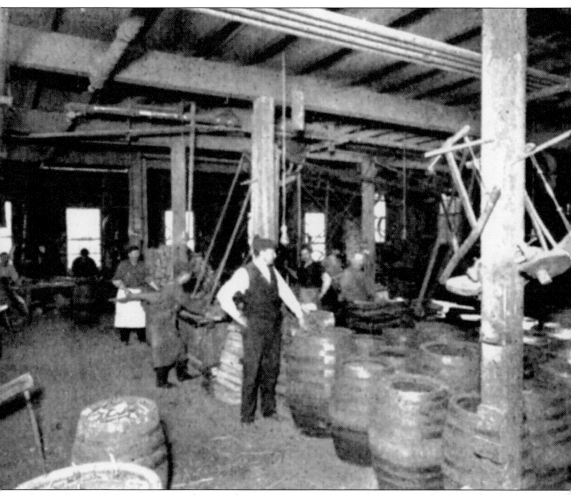

ROLL OUT THE BARRELS. As the Frank Jones Brewery was so large, it made sense for them to have their own cooper's shop. It was here that all of the kegs were made and maintained. The gentleman in the middle is more than likely the foreman. He oversaw the production of all barrels. This was a key part of the brewery. If things did not run smoothly here, the whole production of beer stopped, which meant no kegs and no storage. Today's kegs are made of stainless steel and hold only half of the amount of beer as the wooden barrels did. One can only imagine how heavy full or empty barrels must have been. (Courtesy Rus Hammer.)

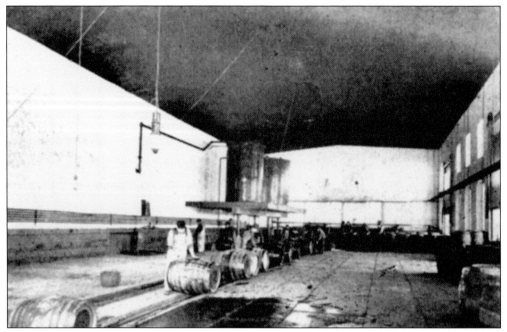

THE KEG-CLEANING ROOM. Before the kegs were first used or after they were returned, they needed to be inspected and washed. The big tanks in the back had a cleaning solution that was sprayed into the bunghole. The hole was corked and the keg was rolled down the line. At the end of the line, it was emptied and rinsed. If there were any leaks, the keg was returned to the cooper's shop for repair. (Courtesy Rus Hammer.)

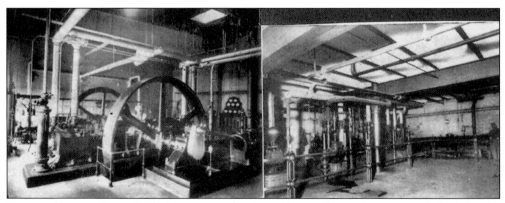

KEEPING THINGS COOL. With the mass production of beer, refrigeration was needed. To let the beer age correctly and keep it from spoiling, it had to stay cool. A smaller brewery could use an icehouse, but with the size of this brewery, that would not do. Fortunately, they were able to use the new technology of refrigeration to keep the beer cold. (Courtesy Rus Hammer.)

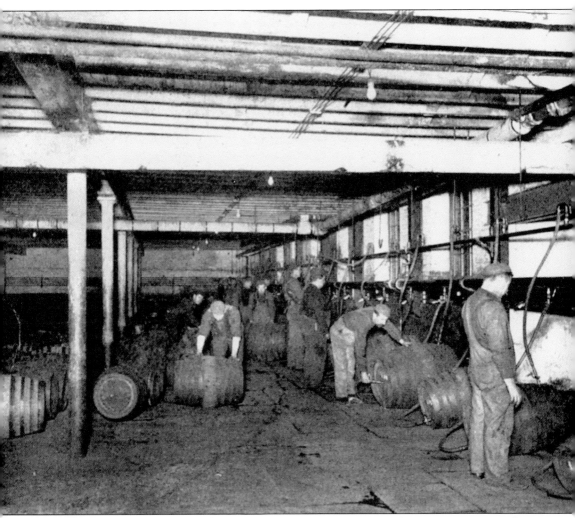

FILL THEM UP. Once the kegs were cleaned and passed inspection, they were sent on to the filling room. There was no machinery to help here. The empty keg was rolled into position, a filling hose was attached to the bunghole, and the keg was filled. After filling, the hole was plugged and the keg was sent to the conditioning room. Conditioning is when the beer is allowed to sit and become carbonated. Notice the light bulbs hanging from the ceiling. Electricity was still new. Frank Jones had a dynamo built on the brewery's property. This supplied the brewery and his house that was a few miles away with electricity. (Courtesy Rus Hammer.)

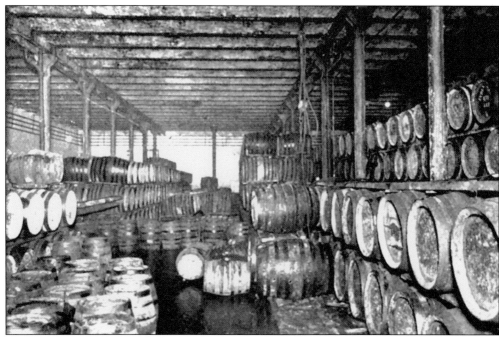

THE CASK ROOMS. After the beer was kegged, it needed to rest. The resting allowed the beer to naturally carbonate. Besides resting, the beer needed to be cool. All cask rooms were kept at an average of 54 degrees. To do this, brewers refrigerated the room in the summer and heated it in the winter. The kegs sat here for a couple of weeks before the beer was bottled on-site or the kegs were shipped to bars or other bottling locations. (Courtesy Rus Hammer.)

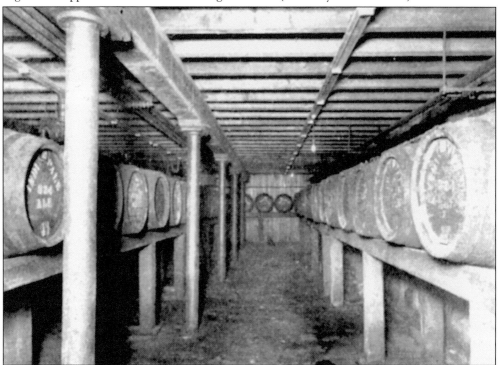

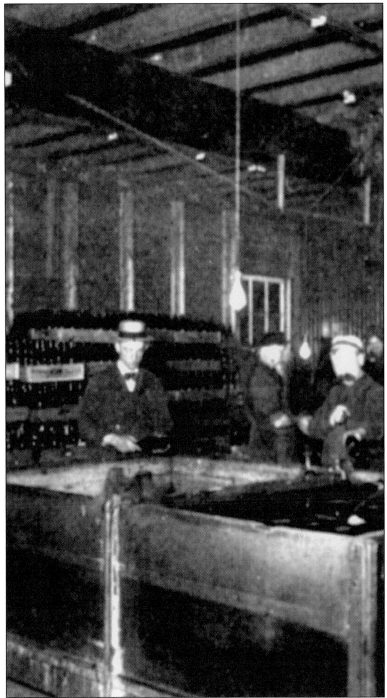

Bottle Washing. All bottles, new or returned, needed to be cleaned before filling. The bottles were submerged in a cleaning solution and scrubbed by hand. The gentleman with the white hat is using a plain old bottlebrush. This had to be a long, tedious, and caustic job. The other gentleman, wearing the hat and tie, was likely an inspector or foreman. Everything had to be perfect. (Courtesy Rus Hammer.)

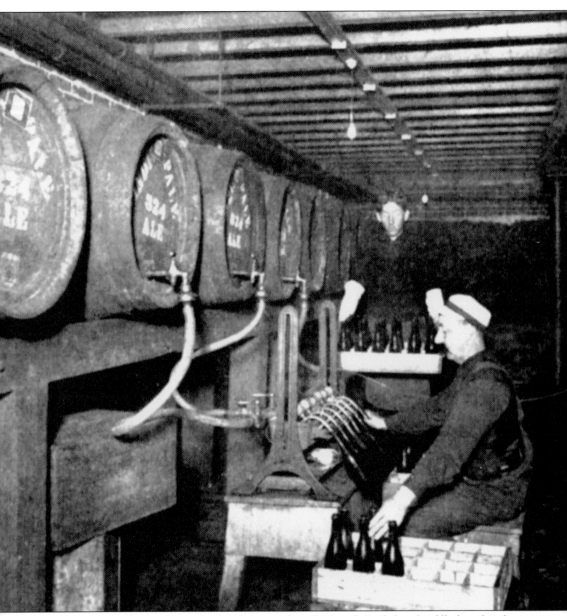

THE BOTTLING ROOM. Even the bottling was done by hand. Each bottler filled six bottles at a time. When one case was full, in came another. Before the assembly line and modern machinery, this was the fastest and most efficient way to do this task. The beer being bottled was probably for local consumption. Beer bound for Boston would be shipped in kegs and bottled at the distributor's location. Otherwise, bottles sent to farther points might break during shipping. (Courtesy Rus Hammer.)

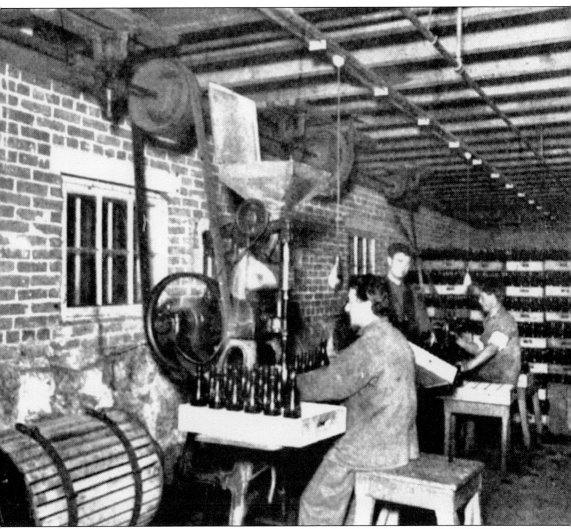

PUTTING A CORK IN THE BOTTLE. Yet another labor-intensive, two-person job was the corking process. After corks were put in the hopper at the top of the machine, a bottle was placed under a sleeve and the cork was inserted. After the cork was put in, it was given to the other sitting worker. This employee's job was to put a wire tie on the cork. This type of corking is what is still used today for champagne. Besides pumps for moving the beer or grinders for the grain, these were likely the only machines used for the production of beer. (Courtesy Rus Hammer.)

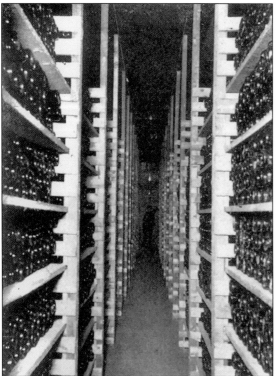

THE RACKING ROOM. Like the kegs, the bottled beer needed to rest. This allowed the beer to naturally carbonate. If this step were skipped, the beer would be flat. The beer was stored like wine, as more beer or ale could be stored in less space than if it had already been packaged in a wooden case. (Courtesy Rus Hammer.)

THE FUTURE. The fact that this room is empty is not a bad thing. The demand for Frank Jones Ale had increased by the end of the 1800s, and because of this, a new racking room was created. This state-of-the-art room was soon filled with full bottles of ale to keep up with the local demand. (Courtesy Rus Hammer.)

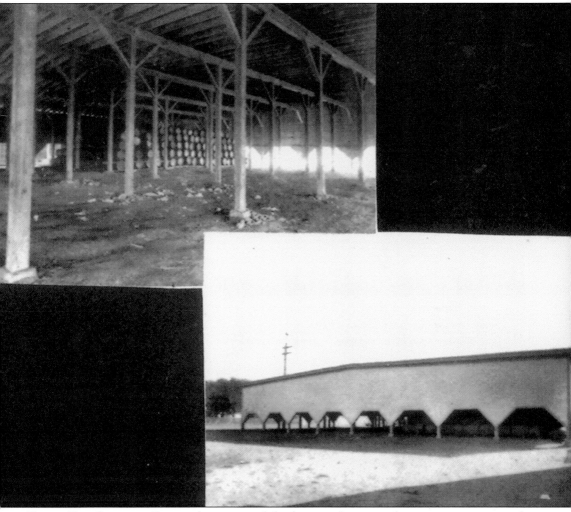

EMPTY KEG STORAGE. Due to the nature of the brewing business, there was a storage need for empty kegs. Hopefully, the demand for brew kept the kegs in circulation, and brewery owners, especially one like Frank Jones, preferred to see this shed more empty than full. A brewery whose storage area for empties was full more often than not was soon out of business. (Courtesy Rus Hammer.)

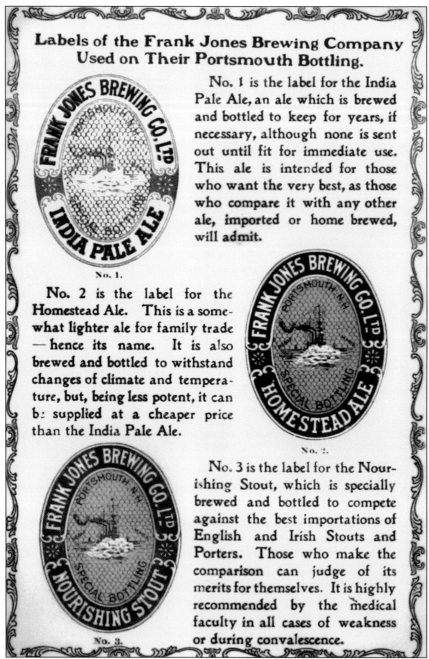

Labels of the Frank Jones Brewing Company Used on Their Portsmouth Bottling.

No. 1 is the label for the India Pale Ale, an ale which is brewed and bottled to keep for years, if necessary, although none is sent out until fit for immediate use. This ale is intended for those who want the very best, as those who compare it with any other ale, imported or home brewed, will admit.

No. 1.

No. 2 is the label for the Homestead Ale. This is a somewhat lighter ale for family trade — hence its name. It is also brewed and bottled to withstand changes of climate and temperature, but, being less potent, it can be supplied at a cheaper price than the India Pale Ale.

No. 2.

No. 3 is the label for the Nourishing Stout, which is specially brewed and bottled to compete against the best importations of English and Irish Stouts and Porters. Those who make the comparison can judge of its merits for themselves. It is highly recommended by the medical faculty in all cases of weakness or during convalescence.

No. 3.

TYPES OF BEER MADE. These were the three types of ales Frank Jones brewed. They were India Pale Ale (IPA), Homestead Ale, and Nourishing Stout. The IPA was their flagship and what put Frank Jones on the map. However, the homestead and stout are worth noting. The Homestead Ale was "a light ale for family trade." It had less alcohol, so it was considered good for the whole family and was also less expensive. The stout was marketed against Irish and English imports. The amazing thing about this ale was it could be marketed as "highly recommended by the medical faculty," which is not something that could be done today. (Courtesy Rus Hammer.)

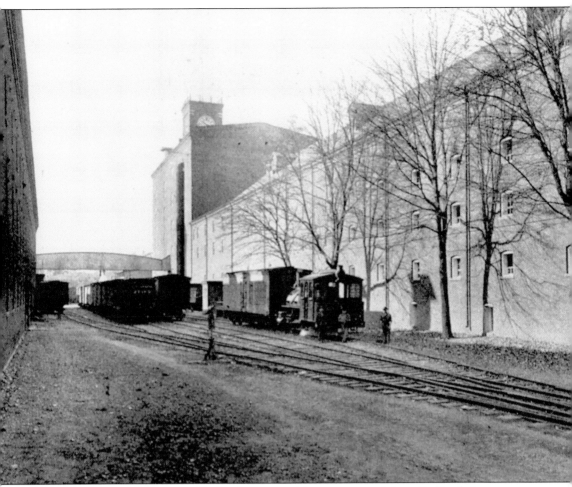

THE FRANK JONES RAILROAD. Back when everything was moved by rail, Frank Jones was president of the Boston and Maine Railroad. It only made sense that his brewery would have its own railroad. It was connected to the Boston and Maine Railroad so that all deliveries could be made directly to customers and to ensure that they were shipping out a freshly finished product. The engine in the picture was used to move cars around the brewery's yard. This way, all deliveries could just be dropped and then moved to where the products could be off-loaded as they were needed. (Courtesy Rus Hammer.)

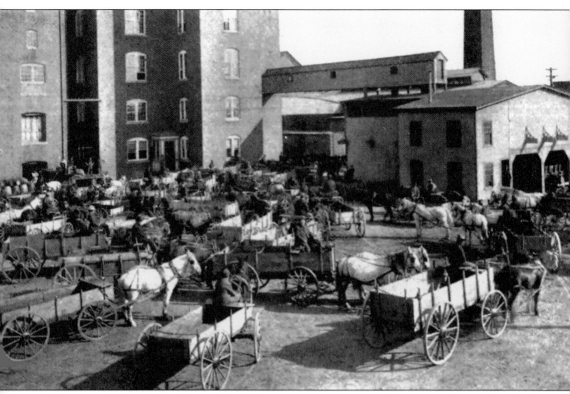

WAITING FOR THE USED GRAIN. Frank Jones was a smart man. He constantly wondered why people would throw away something others would pay for. Having literally tons of used malted grain to dispose of per year, the Frank Jones Brewery found out that the local farmers would buy it and use it as feed for their livestock. This tradition is still adhered to today with all of the major breweries. (Courtesy Rus Hammer.)

Three

THE FRANK JONES EMPIRE

The most successful single brewer in New Hampshire history was the "king of the ale-makers," Frank Jones. A man of ordinary background, Jones was born in Barrington in 1832 and at the age of 17 went to Portsmouth to start his business career. He worked at his brother Hiram's stove store and also traveled the area as a tin peddler. Soon after, he was a partner with his older brother in the stove business, and by 1854, he was operating the business as his own. Though Frank Jones became Portsmouth's most wealthy citizen, he was not the city's first commercial brewer. That honor went to Englishman John Swindell, who started his brewery in 1856. Swindell, although he made good ale, was a failure as a businessman, and it is here that Frank Jones saw his opportunity. He entered into a partnership with Swindell in October 1858 and, in May 1859, bought out Swindell entirely and began his own ale-making career that rose to unprecedented heights. Though Jones's other achievements were equally as spectacular as his ale business, he never forgot his brewery and constantly strove to expand and modernize it. To complement his Portsmouth brewery, Jones bought the Henry Souther Brewery in South Boston for $120,000 in cash in 1875. At its peak, the Portsmouth brewery produced about 165,000 barrels of ale annually and employed 175 people. After Jones's death in 1902, the brewery continued until New Hampshire became a dry state in 1917.

Frank Jones' Improved

COOKING STOVE.

THE above cut represents a new and beautiful Cooking Stove which the subscriber offers to the public as the very best in use. Having been at great expense in getting up this new pattern, sparing neither time or exertion to bring out a Stove that shall give perfect satisfaction, we feel confident, after having had so much experience in the Stove business, in offering this as the most convenient, heaviest, and most economical Cooking Stove in the market. FRANK JONES.
Aug 30 61 Market St.

A FRANK JONES STOVE ADVERTISEMENT, 1856. While Swindell was running his brewery, Frank Jones was running his own business as a dealer in stoves in Portsmouth. In those days, the stove business was on par with that of car dealerships today. The competition was heavy and cutthroat, and among Jones's competitors was his brother Nathan. Soon, Jones abandoned this business and moved on to bigger and better ventures. (Courtesy the Portsmouth Public Library.)

Ale! Ale!! Ale!!!

SUPERIOR PALE, BROWN and AMBER CREAM ALE, at
$6 PER BARRELL.
Also on hand a lot of STOCK ALE, at
JOHN SWINDELL'S
No. 19 Bridge street, near the Concord Depot.
je4 3m Portsmouth, N. H.

A JOHN SWINDELL ADVERTISEMENT, 1856. Before Frank Jones came on the brewing scene in Portsmouth, this Englishman was the city's ale maker. He brewed a good ale but was a poor businessman and likely imbibed too much of his own product. After being bought out by Jones, he briefly revived his brewery. He later died after being hit by a train while saving a little girl. (Courtesy the Portsmouth Public Library.)

A City Directory Advertisement, 1881.
As this advertisement shows, the Frank Jones
Brewing Company not only marketed its own
beer but that of such competitors as the famous
Bass Ale. Jones was too good of a businessman
not to recognize that he could sell not only his
own beer but also English imports. (Courtesy the
Portsmouth Public Library.)

Frank Jones Brewing Company,

——Brewers of Celebrated——

GOLDEN, STOCK,

IMPERIAL CREAM,

--AND--

XXX

ALES.

——ALSO,——

Pale Ale, Porter & Brown Stout.

Importer of Bass' Ales.

OFFICE, 85 Market Street, PORTSMOUTH, N. H.

DEPOT, 147 CONGRESS ST., BOSTON.

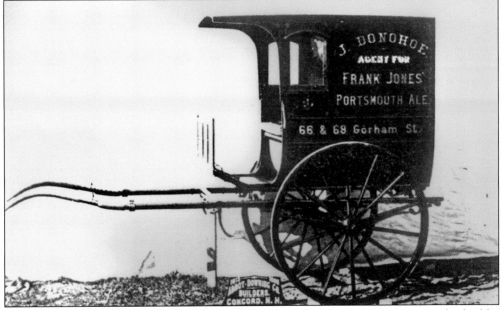

An Abbot-Downing Beer Coach. The Abbot-Downing Coach Company was the builder of this beer coach in the 1880s. The location of the agent is unknown, but it was one of many distributors for Frank Jones throughout New Hampshire and New England. This type of horse-drawn coach was used by the agent who went about taking orders from local saloons and stores, but it was not a delivery vehicle. (Courtesy the New Hampshire Historical Society.)

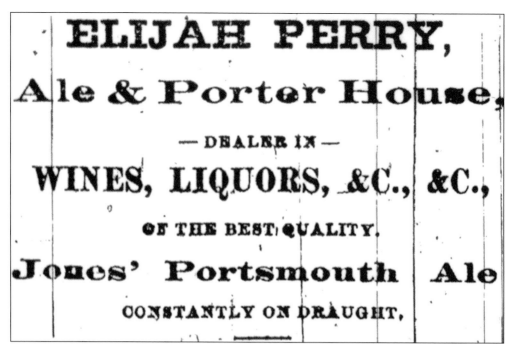

AN ELIJAH PERRY ADVERTISEMENT, 1871. Before the modern era, the newspaper media was about the best and only means to advertise one's business outside the local area. This advertisement for a Manchester alehouse appeared in a Dover newspaper. As it shows, not only did Perry's ale and porterhouse serve wine and liquor, but they also had Jones' Portsmouth Ale "constantly on draught." (Courtesy the Dover Public Library.)

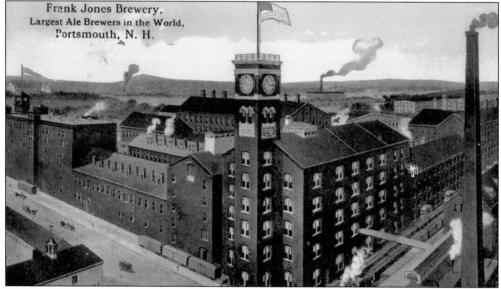

THE FRANK JONES BREWERY, C. 1900. This postcard view shows the brewery near the time of Jones's death in 1902. Previously, in 1889, Jones had sold it to an English concern for $6.3 million but was still its manager and driving force. Jones always stuck to brewing ale, and if his brewery was not the largest in the world, it was undoubtedly the largest in the nation. (Courtesy Rus Hammer.)

H. D. CILLEY

CARBONATOR

And Wholesale Dealer in

Malt and Spirituous Liquors

Agent for The Frank Jones Brewing Co., Rueter's Sterling Ale, Pabst Milwaukee Beer, A. J. Houghton Co. Pavonia Beer, and The American Rochester Bohemian Beer, Old Thompson, Jackson, and James E. Pepper Whiskeys.

AN H. D. CILLEY ADVERTISEMENT, 1899. This wholesale dealer in Laconia advertises a good sampling of some of Jones's competition. Of the breweries listed, Pabst Milwaukee still operates today and is currently the nation's fourth largest brewer. Consolidation by larger breweries, combined with Prohibition, was the demise of many local breweries.

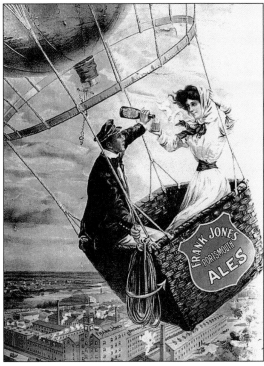

UP, UP, AND AWAY. By the time this advertising lithograph was produced c. 1900, Jones's business had soared. There is no doubt that Jones's ales carried customers' taste buds to great heights, but one might question the wisdom of operating a hot-air balloon while drinking. This advertisement is a forerunner of today's advertisements that often use extreme sports to capture the bold spirit of the beer they promote. (Courtesy Rus Hammer.)

FRANK JONES BILLHEAD, C. 1900. The cruiser depicted on this billhead is very fitting. The Portsmouth Naval Shipyard was located just three miles from the brewery, and just like today, it was a driving force in the city's economy. This was also just about the time, or shortly thereafter, of the Spanish-American War, when U.S. Navy cruisers, under the celebrated Admiral Dewey, achieved their crushing victories. (Courtesy Rus Hammer.)

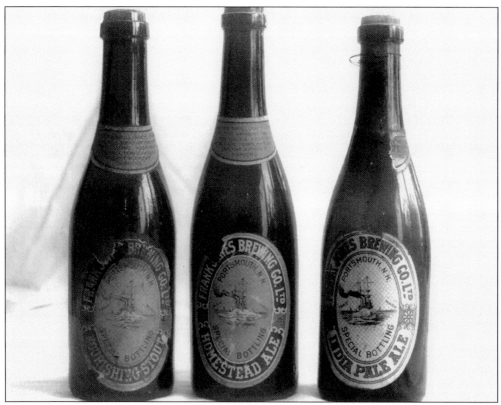

FRANK JONES BOTTLES, C. 1900. These three bottles represent the bestsellers for Frank Jones. IPA was his No. 1 seller, followed by homestead and then the stout. These bottles are a great representation of the bottles being filled and corked on pages 40 and 41. Notice on the IPA bottle that some wire remains that was used for the corking process, as well as the popular cruiser logo on the label. (Courtesy Rus Hammer.)

A FRANK JONES LITHOGRAPH, 1902. In 1902, the use of a child's image was not taboo in alcohol-related advertisements. If a brewer tried to use this same format today, even in such a mild form as this New Year's greeting, the repercussions would be unimaginable. Though beer advertisements often touted their product for family use, the growing Prohibition movement soon brought this to a halt. (Courtesy Rus Hammer.)

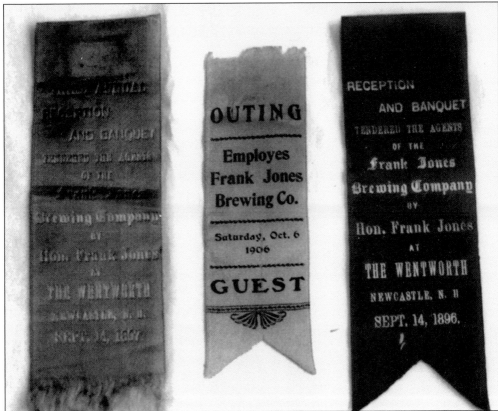

FRANK JONES RIBBONS, 1896–1906. Even though Frank Jones was a very wealthy and powerful man, he always remembered the people that he employed. These ribbons were the ticket to his annual parties and outings, often held at his lavish Wentworth by the Sea hotel in New Castle. The ribbon in the middle was for the annual employee outing. The other two were reserved for receptions for agents of his ale. (Courtesy Rus Hammer.)

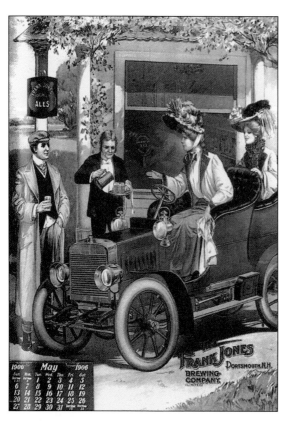

A Frank Jones Calendar, 1906. Perhaps more than any other view, this calendar scene shows how greatly the times have changed in regards to alcohol consumption. In 1906, the issue of drinking and driving was of little concern. It took another 70 years or so to reverse this way of thinking. (Courtesy Rus Hammer.)

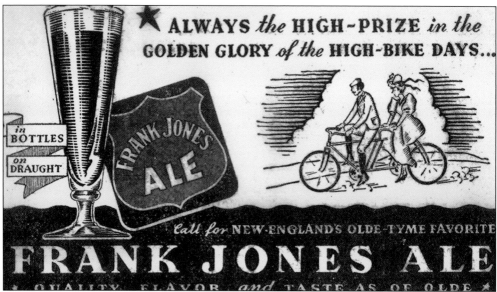

A Frank Jones Advertisement, c. 1938. This post-Prohibition advertisement harkens back to the "olde-tyme" days when Jones was still alive and his ale was the drink of choice for many New Englanders. Though brewed under his name, and supposedly using his old recipe, the beer was brewed at the old Eldredge Brewery and simply could not capture the glory of its past, finally ceasing operations in 1950. (Courtesy Rus Hammer.)

FRANK JONES, 1882. It was in 1858 that Jones started to work with John Swindell and began building his ale legacy. Besides being a brewer, he was mayor of Portsmouth, congressman, president of the Boston and Maine Railroad and Granite State Fire Insurance Company, and proprietor of the Rockingham and Wentworth by the Sea hotels and numerous other businesses. (From Hurd's *History of Rockingham and Strafford County*, 1882.)

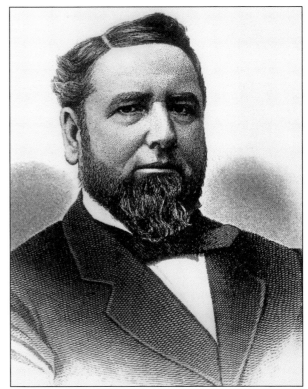

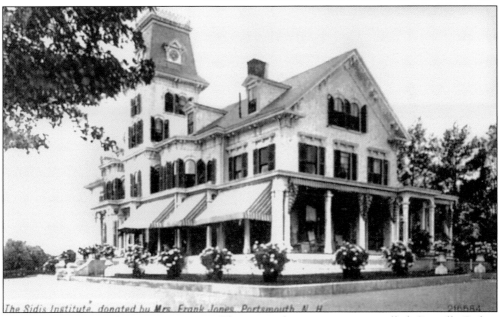

THE FRANK JONES MANSION, C. 1900. The original estate property, called Gravelly Ridge, was purchased in 1866 from Charles Myers for $10,000. It was located very close to the site of an inn where Jones stayed when he first came to town in 1849. The property was renamed Maplewood Farm, and what is now Maplewood Avenue was Jones's private road to the brewery. (Courtesy Rus Hammer.)

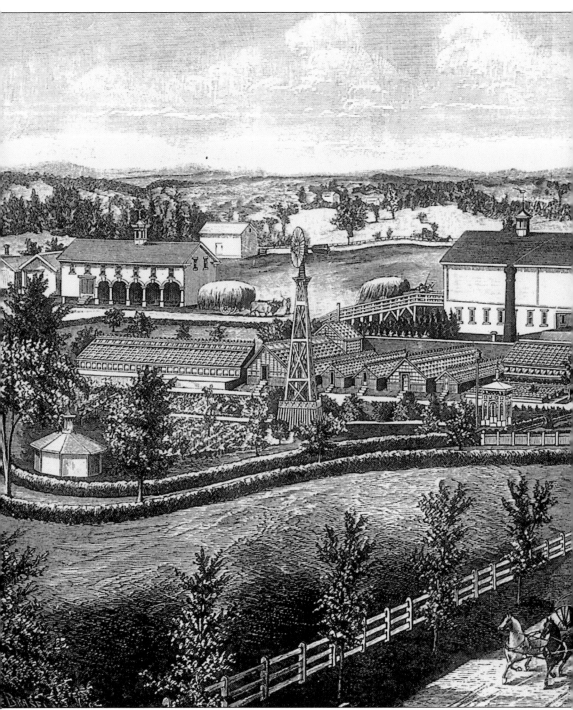

MAPLEWOOD FARM, 1882. This lithograph of Maplewood Farm shows what Jones's ale could buy. What started out as a single purchase of land soon grew into a 2,000-acre horse farm, one of the largest in the country. The impressive green houses were staffed by upwards of 100 gardeners to keep fresh rare and tropical flowers in the main residence year-round. In addition to his brewery and his hotels, Jones also loved his livestock, especially horses. He kept them well cared

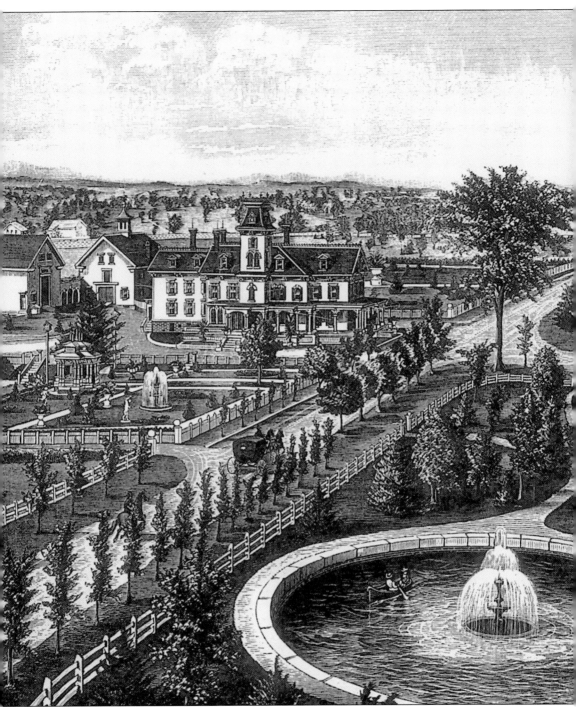

for and provisioned in the elaborate barns shown here, and he was an avid horse racer. Legend has it that he once fired a brewery teamster for applying the whip too harshly to a team of his draft horses. In typical Frank Jones manner, his property was open to the public. (From Hurd's *History of Rockingham and Strafford County, 1882*.)

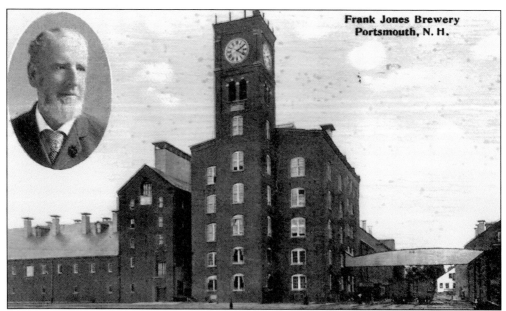

A Frank Jones Postcard, c. 1900. The 140-foot clock tower of the brewery was built by Major Abbot of Dover in 1887. The clock measured 11 feet in diameter and had the second largest illuminated dial in New England. It was removed before World War II. When fire ravaged the brewery in later years, the clock tower was lost. The building to its left still stands today. (Courtesy Rus Hammer.)

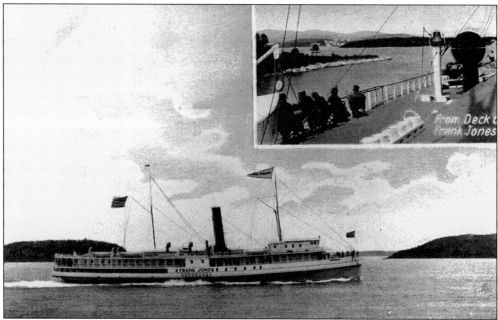

The Frank Jones, c. 1895. Frank Jones's name appeared on more than just his companies. It was also given to several ships, including this steamer, which carried passengers up and down the Maine coast. The steamer was completed in 1892 by the Bath Iron Works for the Maine Central Railroad. The postcard picture was taken while the ship was in Bar Harbor. (Courtesy Rus Hammer.)

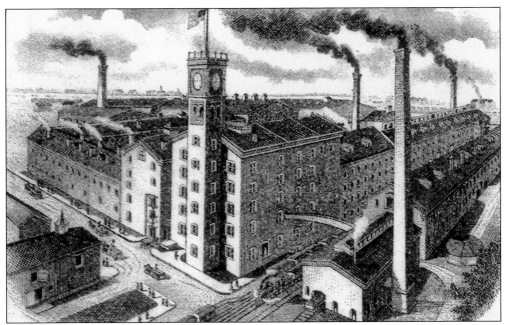

THE FRANK JONES BREWERY, C. 1900. From 1859 to 1888, Frank Jones was the sole owner of the brewery. This could be considered the heyday of the brewery. It was during this time that the majority of the building and expansion of the brewery took place. Even though the brewery was sold in 1888 and continued to operate until 1917, the majority of its construction was complete. (Courtesy Rus Hammer.)

A FRANK JONES ADVERTISEMENT, c. 1939. New Hampshire adopted the Volstead Act (18th Amendment) in 1917. When this happened, the brewery shut down and remained closed until 1933, when the repeal of Prohibition was passed. This wholesome advertisement, ironically depicting a car with a Massachusetts license plate, appeared in 1939 for the new Frank Jones Ale. The name, both a Portsmouth and state institution, was kept alive until 1950. (Courtesy Rus Hammer.)

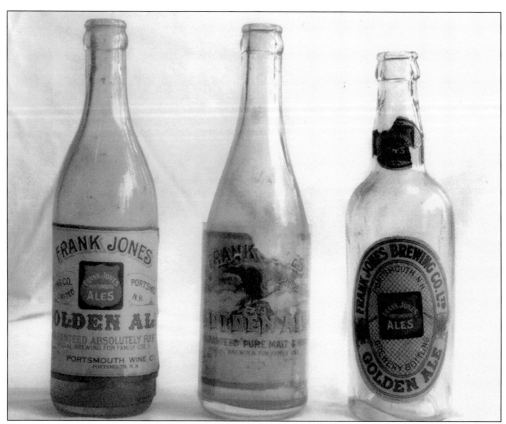

FRANK JONES BOTTLES, C. 1895–1915. Golden ale was the next big thing for Frank Jones before Prohibition. The two bottles in the center and to the left read, "Special brewing for family use," which usually meant it was lower in alcohol compared to IPA. The middle bottle, with the bald eagle logo, is likely older, while the bottle to the right dates from the post-Prohibition era. (Courtesy Rus Hammer.)

FRANK JONES BILLHEAD, 1915. This item is dated two years before the closing of the brewery. Brewery operators fought Prohibition advocates to the bitter end, and they always thought that their temperance efforts would fail. When the brewery was operating at its height, there were almost 200 workers employed there. Its closure at that time would have been a huge blow to the local economy. (Courtesy Rus Hammer.)

ELDREDGE PORTSMOUTH ALE, C. 1933. Once Prohibition ended, the Eldredge Brewery made a run with the original secret formula of Frank Jones Ale, its former master brewer being hired when production was resumed at the old brewery. This continued until 1937, when the brewery changed its name to Frank Jones Brewing Company. (Courtesy Rus Hammer.)

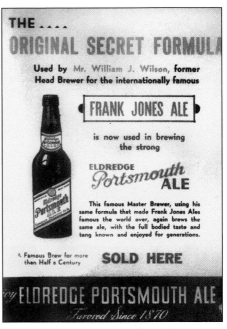

THE
ORIGINAL SECRET FORMULA

Used by Mr. William J. Wilson, **former Head Brewer for the internationally famous**

FRANK JONES ALE

is now used in brewing the strong

ELDREDGE *Portsmouth* ALE

This famous Master Brewer, using his same formula that made Frank Jones Ales famous the world over, again brews the same ale, with the full bodied taste and tang known and enjoyed for generations.

A Famous Brew for more than Half a Century **SOLD HERE**

ELDREDGE PORTSMOUTH ALE
Favored Since 1870

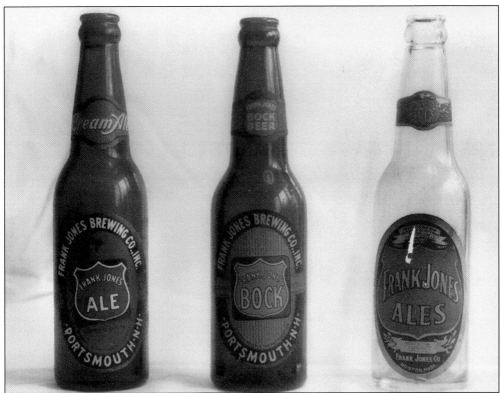

FRANK JONES BOTTLES, C. 1939. Over the 76 years that Frank Jones Ale was produced, lager beers were king in Europe and much of America, but not England and New England. The lager influence did not hit New Hampshire until the late 1800s and early 1900s. It was the Frank Jones Brewery that kept the old England style of ales alive. (Courtesy Rus Hammer.)

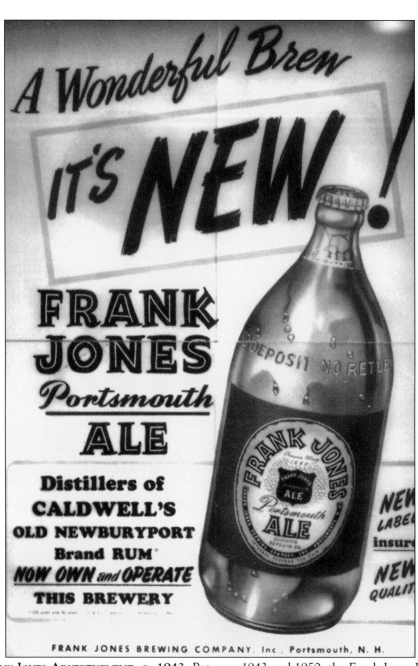

A FRANK JONES ADVERTISEMENT, C. 1943. Between 1943 and 1950, the Frank Jones Brewing Company was under yet another ownership group. The Caldwell Distillery was based in nearby Newburyport, Massachusetts. However, after only seven years they ceased production. By this time, consolidation and competition was too great, and many local breweries could not survive. Another factor was the country's changing tastes. The new generation of beer drinkers included many young men that had fought during World War II and were quite used to the much lighter lager beer that was often part of their rations. With the new trend toward beer, and the decline of the older generation raised on ale, Frank Jones Ale soon became a thing of the past. (Courtesy Rus Hammer.)

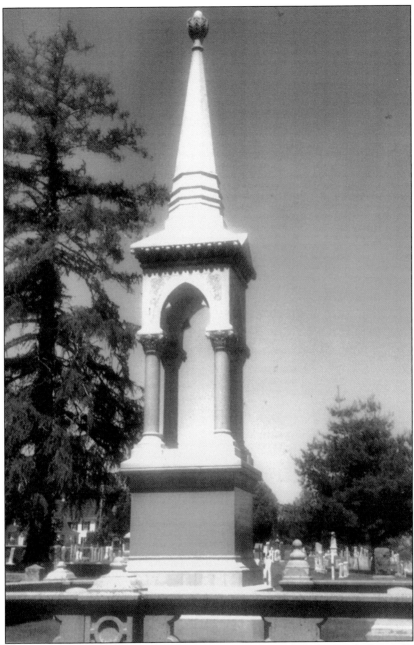

THE FRANK JONES PLOT. Along Sagamore Avenue in Portsmouth is the South Street Cemetery. It is here that Frank Jones was laid to rest. Jones died on October 2, 1902, at 70 years old. Frank Jones's older brother Hiram, who committed suicide by slitting his throat on July 2, 1859, is also buried here. Along with them are Frank's wife, Martha, adopted son Edward, and Martha's mother, Louisa Leavitt. Their monument is one of the largest in the cemetery. The plot was originally purchased in 1870, and a monument 16 feet high was erected. However, just like everything Frank Jones touched, it had to be the biggest and the best. In 1898, in poor health and sensing the end, Jones built this new monument. Cut in Quincy, Massachusetts, it measures 29 feet high.

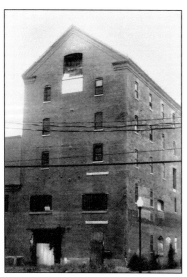

THE REMAINS OF THE FRANK JONES BREWERY TODAY. Fire over the years has destroyed much of this once beautiful brewery. Although a good portion has been lost, many buildings still exist. Beginning in the early 1990s, developers saw what could be a gold mine in office space. Over the years, buildings have been updated and converted to offices, coming back to life in a modern way that might please Frank Jones.

THE FRANK JONES BREWERY, 1992. The name Frank Jones in Portsmouth history will likely never die. It gained a brief revival when his great-grandson reestablished the family business as a microbrewery in 1992. Despite its renowned name, this was a bad time for the microbrewery business, and the plant was shut down after brewing for one year. Its machinery was subsequently purchased for use in the new Smuttynose Brewery in 1994.

Four

Portsmouth's
Other Breweries

The legacy of Frank Jones is so pervasive that the fact that Portsmouth had two other important breweries during this time is often forgotten. The first and largest of these was the Eldredge Brewery, located on what is now Bartlett Street, across from the Frank Jones Brewery. This brewery was first established *c.* 1860 and operated under the name of the M. Fisher Brewing Company. It was operated by Marcellus Fisher Eldredge, the son of Heman Eldredge. The Eldredge family came to Portsmouth from Chatham, Massachusetts, and were involved in a variety of trades. Not only were they dealers in fish, corn, and grain, but they also held part interest in several schooners and were agents for a packet that ran between Portsmouth and New York. The M. Fisher Brewing Company operated under this name until 1870, when it was reorganized as the Heman Eldredge and Son Company. In 1874, it shortened its name to the Eldredge Brewing Company, a name it kept until halting operations in 1916.

The Portsmouth Brewing Company, with its operations located on Bow Street, was first established in 1871 as the Harris and Mathes Company. By 1873, the brewery was operated by Arthur Harris, and by *c.* 1876, it was renamed for the final time as the Portsmouth Brewing Company. While little is known about this brewery, and despite being dwarfed in publicity by its larger rivals, the Portsmouth Brewing Company brewed a good product and flourished in Portsmouth for many years before ceasing operations in 1917.

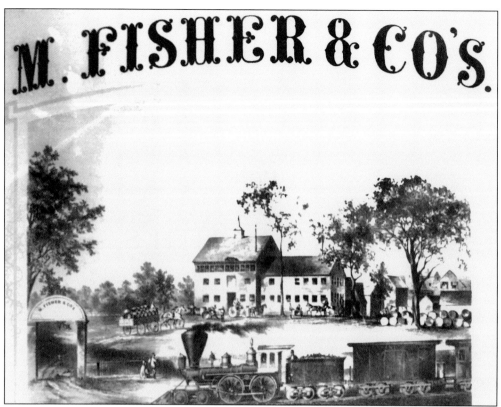

AN M. FISHER ADVERTISEMENT. This rare lithograph is one of the few known artifacts from the early days of the Eldredge family brewing business. Before the family started brewing, Heman Eldridge and his family, including sons Marcellus and Heman, came to Portsmouth in 1852. Marcellus first worked at his father's store as a clerk and soon worked at the newly opened brewery *c.* 1861. (Courtesy Rus Hammer.)

J. & H. ELDREDGE,
DEALERS IN
CORN, GRAIN AND FLOUR,
AND
FISH OF ALL KINDS.
AGENTS FOR
N. York & Portsmouth Packets.
77 and 79 Market Street, Portsmouth, N. H.

AN ELDREDGE ADVERTISEMENT, 1857. The Eldredge family dealt in other food commodities before going into the brewing business, as demonstrated by this 1857 city directory advertisement. Used in the Eldredge business were two 138-ton schooners, one of which was named *Catharine*, built by the famed clipper ship builders Fernald and Pettigrew. One of the commodities the Eldredges may have dealt in were hops, which perhaps inspired them to become brewers. (Courtesy the Portsmouth Public Library.)

A ELDREDGE BREWING COMPANY
LITHOGRAPH, C. 1890. In a day when there
was no television or radio, print media in
many varied forms was second only to word-
of-mouth advertising as a way to market
product. Note how the entire family, child
and pet included, is depicted here, in stark
contrast to today's advertising practices. The
young lady at the right may be a server or
perhaps a friend. (Courtesy Rus Hammer.)

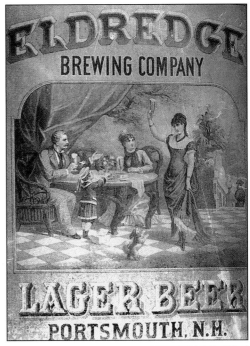

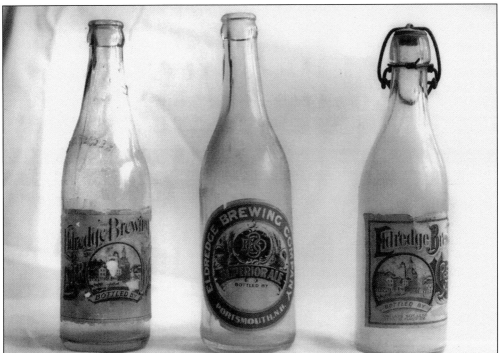

ELDREDGE BREWERY BOTTLES, C. 1900–1915. These bottles depict the various types of beer
brewed by the Eldredge Brewery. In the center is their Superior Ale bottle, with the stylized
EBC logo. On either side are several types of bottles for their lager beer, both of which depict
views of the Eldredge Brewery complex. Note that the bottle to the right still has its wire cap
holder in place. (Courtesy Rus Hammer.)

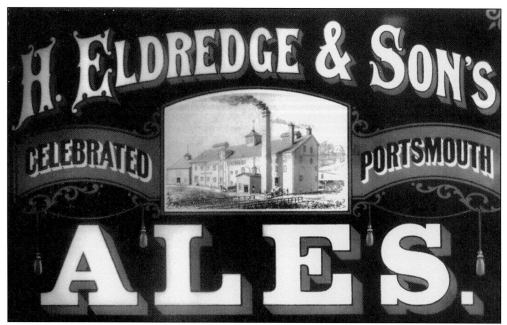

AN ELDREDGE BREWERY LITHOGRAPH, C. 1872. This advertising lithograph depicts the Eldredge Brewery (see detail below) after it had undergone some expansion from its early days. The brewery was expanded again in 1878, a sure indicator that the Eldredges were having no problem keeping up with the Joneses. The Eldredges were not as wealthy as Frank Jones, but they were equally committed to keeping their brewery as modern as possible. In fact, they bested Jones in several technological areas, being the first brewery in Portsmouth to install telephone service (1881) and the first to install machinery to make ice for cooling beer (1890). Despite this competition, Marcellus Eldredge and Frank Jones remained close friends and, for the better part of their careers, political allies. (Courtesy Rus Hammer.)

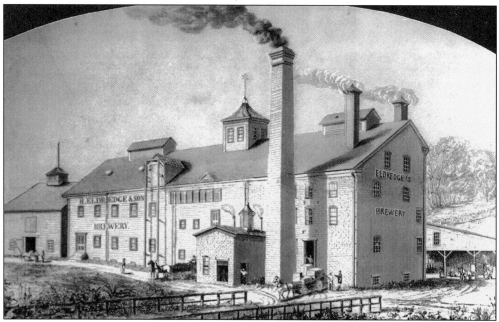

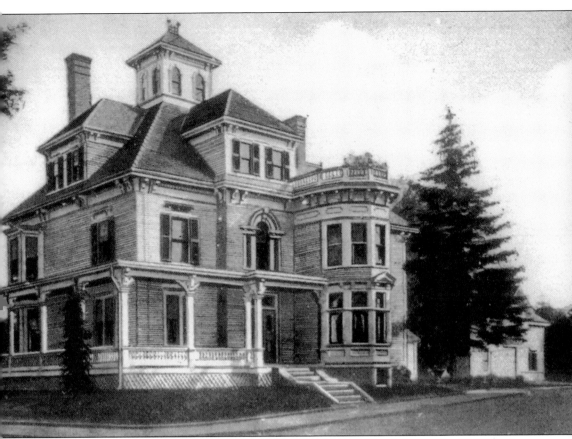

THE ELDREDGE HOUSE. Not quite as ostentatious as the estate of Frank Jones, the Old Eldredge House was nevertheless an impressive one, as shown by this old postcard view. It was located on the corner of Miller and Merrimack Streets. When it came to wealth, Marcellus Eldredge never matched that of his friend, and few in the state could. However, he still ranked in the upper crust of Portsmouth society, and with Jones, he traveled to such faraway elite vacation spots as Hot Springs, Arkansas. While Eldredge, also like his fellow brewer, served as city mayor, historian Ray Brighton has aptly stated that "but for Jones, Eldredge would have ruled Portsmouth." (Courtesy Rus Hammer.)

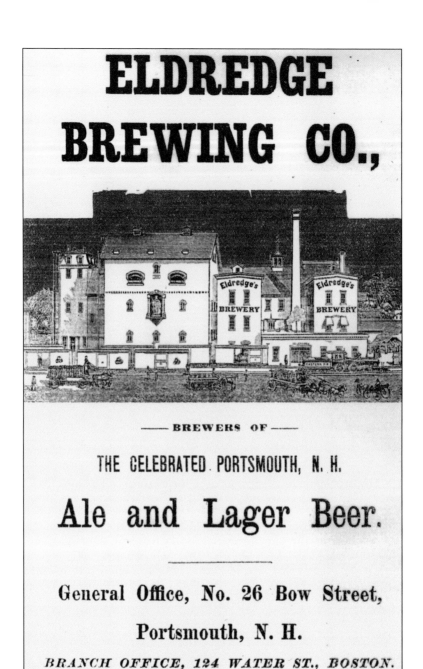

ELDREDGE BREWING CO.,

—— BREWERS OF ——

THE CELEBRATED PORTSMOUTH, N. H.

Ale and Lager Beer.

General Office, No. 26 Bow Street,

Portsmouth, N. H.

BRANCH OFFICE, 124 WATER ST., BOSTON.

AN ELDREDGE BREWING COMPANY ADVERTISEMENT. This advertisement in the city directory for 1888 shows the Eldredge Brewery at its height of prosperity. The brewery underwent substantial expansion and modernization since its early days, and it was the second largest brewery in the state, ranking behind Frank Jones. Interestingly enough, while Jones stayed with ale brewing, Eldredge brewed not only ales, but also porter and lager beer. With the rapid influx of German immigrants into the United States in the mid-19th century, English ales fell off in popularity and soon lager beer became king. Because of this, German influence in American breweries grew considerably and took hold in every aspect of the brewing business. Even brewery buildings were German influenced. Note the statue on the front of the Eldredge Brewery at the left. (Courtesy the Portsmouth Public Library.)

KING GAMBRINUS. The Eldredge Brewery was unique in New Hampshire for prominently featuring King Gambrinus, the patron saint of beer, on its outer wall. Such statues were common on American breweries, and it was similar in appearance to one depicted here for the August Wagner Brewery in Columbus, Ohio. Since the demise of the Eldredge Brewery, locals can still recall the statue, but its whereabouts are unknown. (Courtesy Andy Henderson-Lost Ohio.)

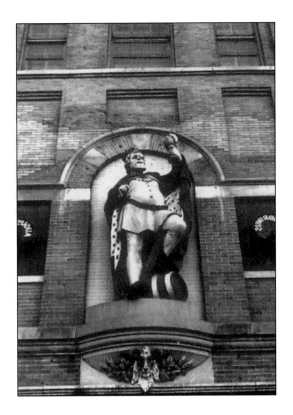

ELDREDGE BREWING CO.,

——BREWERS OF——

The Celebrated Portsmouth, N. H.,

ALE, PORTER AND LAGER BEER.

General Office, 26 Bow Street,

PORTSMOUTH, N. H.

BRANCH OFFICE, 124 WATER STREET, BOSTON

AN ELDREDGE ADVERTISEMENT, 1881. While Eldredge was a player in the brewing business of New Hampshire, it also worked to expand its business to neighboring states. As this city directory advertisement shows, the Eldredge Brewery also had a branch office in Boston. This was likely established in an effort to keep pace with Frank Jones, who owned his own South Boston brewery. (Courtesy the Portsmouth Public Library.)

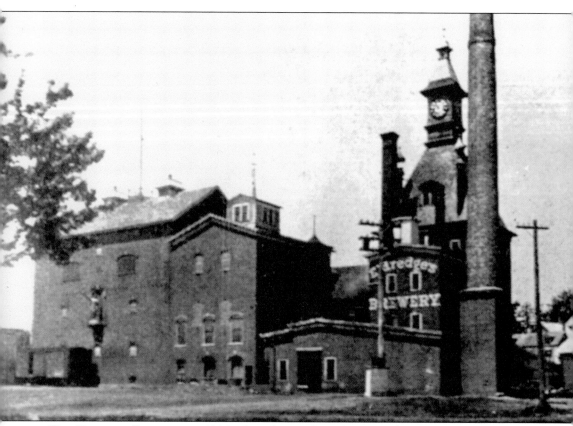

THE ELDREDGE BREWERY, C. 1900. Complete with its King Gambrinus statue (visible at the far left on the brewery wall), this view shows the Eldredge Brewery in its final form. Note the elaborate clock tower to the right. Marcellus Eldredge and his brothers were as fanatical about their brewery as Frank Jones was when it came to both style and substance. Not only was their building architecturally interesting, but they also installed the most modern brewing equipment whenever possible. Not to be forgotten were the brewery workers themselves. All indicators point to the fact that the Eldredges paid their workers fairly and treated them well. In July 1884, when the coopers went on strike at all of Portsmouth's breweries to increase their daily wages from $2.50 to $3.00, the Eldredges were the first to meet their demands. (Courtesy Rus Hammer.)

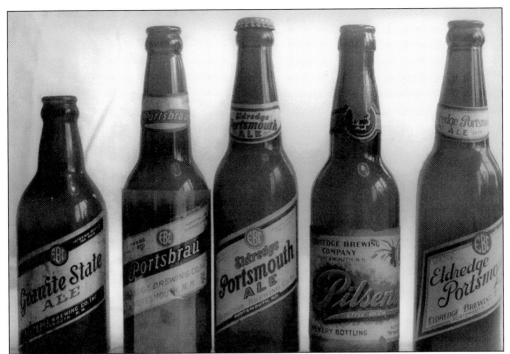

ELDREDGE BOTTLES, C. 1935. These bottles show the types of beer and ale brewed by Eldredge in the post-Prohibition era. Closed down in 1917 after New Hampshire went dry, they were able to reopen once Prohibition ended in 1933. From 1933 to 1937, the business operated under its old name, but in 1937, with all the Eldredges gone, the brewery resurrected the Frank Jones name until ceasing operations entirely in 1950. (Courtesy Rus Hammer.)

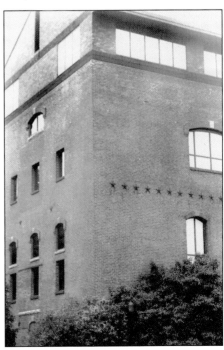

THE ELDREDGE BUILDING. Parts of the old Eldredge Brewery complex are still in use today as an office complex. All but the upper portion of the brickwork was part of the original building, as are all but the upper window frames. The stars on the side are cast iron and serve as decorative anchors that hold supporting iron rods that run through the structure's interior to the opposite wall.

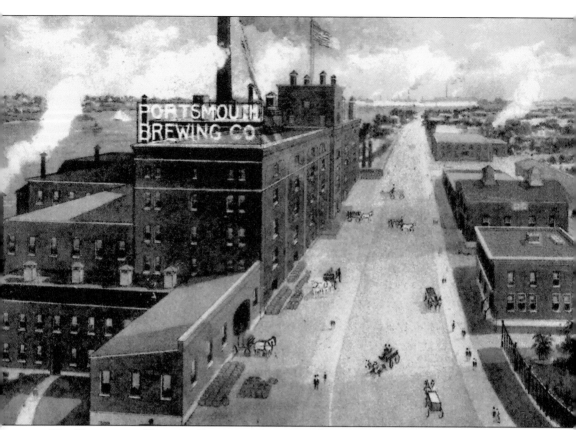

THE PORTSMOUTH BREWING COMPANY. This postcard view of the Portsmouth Brewing Company dates from *c.* 1900 and shows the company's waterfront location on Bow Street. Note the many horse-drawn beer wagons on the street out front coming in for deliveries, and the many casks, probably empties, stacked outside. (Courtesy Rus Hammer.)

A PORTSMOUTH BREWERY ADVERTISING CARD, C. 1900.
Cleverly depicting a beer stein within a beer stein,
this advertising card shows a heavy German influence.
Like the Eldredge Brewery, the Portsmouth Brewing
Company also brewed a wide variety of beers, including
ales and lager. (Courtesy Rus Hammer.)

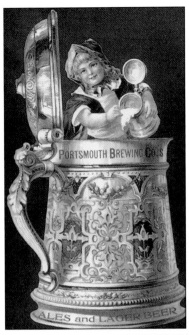

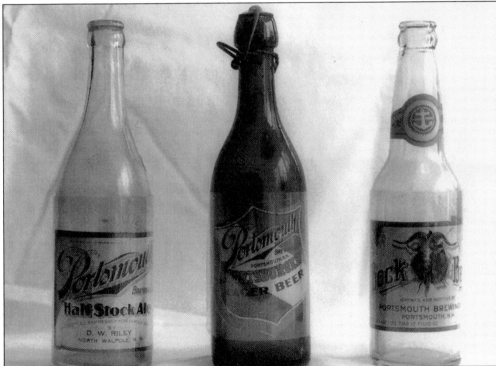

PORTSMOUTH BREWING COMPANY BOTTLES. These bottles, dated c. 1900, show the wide variety of beers produced by the Portsmouth Brewing Company. One of their staple beers was the creatively named Portsburger Lager (center), while their Bock Beer (right) sported an unusual ram's head logo. Note that the half-stock ale (left) was "bottled expressly for family use" by D. W. Riley at North Walpole, New Hampshire. (Courtesy Rus Hammer.)

75

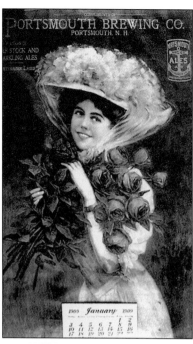

A Portsmouth Brewing Company Calendar, 1909. Fashionable young ladies have been used for quite some time to advertise a brewer's product, and the Portsmouth Brewing Company was no different in this regard. However, by this time, brewers in New Hampshire were living on borrowed time. Just eight years later, in 1917, the Portsmouth Brewing Company went out of existence when New Hampshire became a dry state. (Courtesy Rus Hammer.)

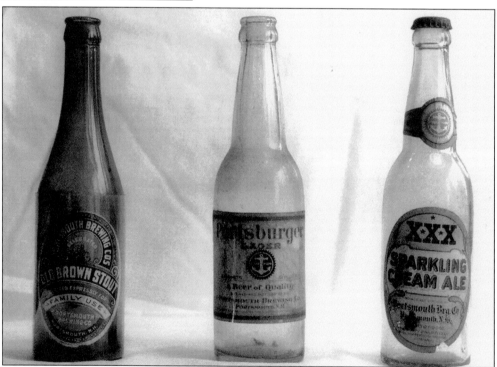

Portsmouth Brewing Company Bottles, c. 1910. Right up to the end, the Portsmouth Brewing Company produced a variety of brews. In the center is the bottle for their flagship Portsburger Lager, while to the right is a bottle for their well-advertised Sparkling Cream Ale. To the left is an example of their Old Brown Stout brew, still hailed for its "family use" even as the temperance movement was gaining considerable momentum. (Courtesy Rus Hammer.)

PORTSMOUTH BREWING COMPANY ADVERTISEMENTS, C. 1890–1900. These city directory advertisements are typical of the day and hail the celebrated types of brew the Portsmouth Brewing Company offered its customers. The ad to the right is the older of the two and is interesting in that it seems to show that the brewery's owner and president, Arthur Harris, resided in New York. The advertisement below shows the company's expansion to larger quarters on Bow Street, and it depicts its very appropriate anchor logo. Despite being third in size in Portsmouth alone, the brewery always remained a competitor for Jones and Eldredge. However, just how small their brewing business was by comparison can be quickly discerned from tax records. In 1896, the Frank Jones Brewery paid the city $24,920 in taxes, while Eldredge paid $2,695, and the Portsmouth Brewing Company paid only $1,123. (Courtesy the Portsmouth Public Library.)

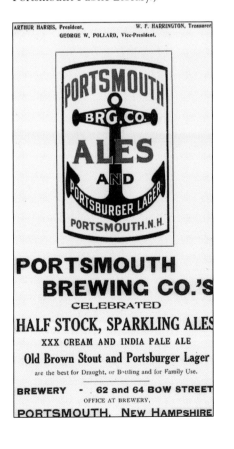

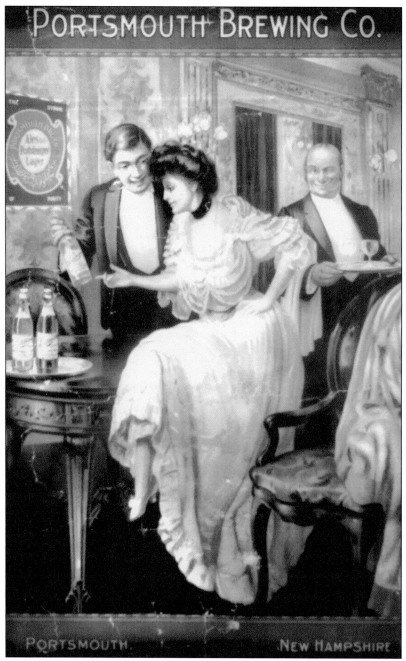

A PORTSMOUTH BREWING COMPANY LITHOGRAPH. Elegant prints such as this one, dated *c.* 1890, were common advertising tools of the day and were an art form that was perfected by American brewers. In a bid to sell as much beer as possible, it was necessary to promote its consumption among the elite in society, both men and women. Notice that the beer bottles in the advertisement look almost like wine bottles, while the glasses on the tray the butler is carrying are definitely not beer glasses. Note too the wink and rather sly look on the butler's face. He obviously knows that his master will impress the lady by offering her a drink of Portsburger Lager. (Courtesy Rus Hammer.)

Five

BREWERIES OF THE PAST IN OTHER REGIONS

In addition to the breweries already described, only four other cities in New Hampshire are known to have had breweries: Manchester, Walpole, Derry, and Moultonborough. The fact that Manchester, a thriving mill town, developed a solid brewing business is quite natural. Wherever there are mills, there are factory workers who need their thirst quenched. The city's earliest successful brewery, after the short-lived operations of R. V. Burt and Michael Prout, was that of Haines and Wallace, which was begun *c.* 1864. Later operating as the Amoskeag Brewery, this concern went out of business in 1877. More enduring was the brewery established by Cyrus Dunn in the Bakersville section of town on Hancock Street *c.* 1875. It was subsequently taken over by Carney and Lynch in 1879, later becoming the New Hampshire Brewing Company. This brewery was bought by True Jones, the brother of Frank Jones, in 1894 and continued in operation under his name until the state went dry in 1917, and they closed their doors.

More surprising is the commercial brewery that developed in the small town of Walpole on the Vermont border. This brewery, begun in 1876 by Walker and Blake and Company, had a tumultuous history, operating under eight different names and suffering several fires before going out of business in 1907.

Two other breweries that operated in the state in the more recent past were the Nutfield Brewing Company of Derry and the Castle Springs Brewery in Moultonborough. The former operated from 1995 to 2003, while the later brewed from 1996 to 2001.

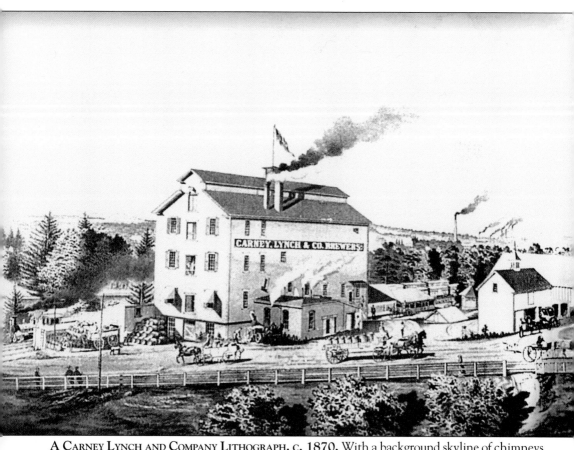

A CARNEY LYNCH AND COMPANY LITHOGRAPH, C. 1870. With a background skyline of chimneys belching smoke, this view shows just how industrialized and successful Manchester had become by the end of the 19th century. Almost every city of importance and size in the Midwest and New England boasted a brewery or two, and Manchester was no exception. Interestingly, the brewmaster for Carney and Lynch from 1879 to 1881 was William "Billy" Moat, a former employee of the Frank Jones Brewery in Portsmouth. After his stint with Carney and Lynch, Moat returned to Frank Jones for the remainder of his brewing career. (Courtesy Rus Hammer.)

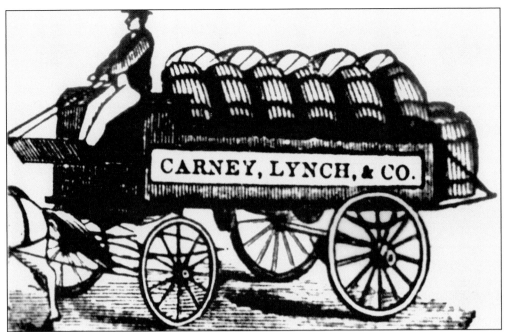

A CARNEY AND LYNCH BEER WAGON, C. 1880. While New Hampshire's rapidly growing railroad system eventually allowed brewers to get their product to a larger market, the majority of their brews were still consumed locally. Beer and ale were transported about town in wooden casks by horse-drawn wagons such as the one depicted in this woodcut, which appeared in a Carney and Lynch advertisement *c.* 1880.

AN AMOSKEAG BREWERY ADVERTISEMENT, 1864. This city directory advertisement demonstrates that this brewery strictly produced the traditional ales and porter for its customers. From 1864 to *c.* 1877, the Amoskeag Brewery ruled Manchester without competition. However, when a rival brewery later operated by Carney, Lynch, and Company was established in 1877, Amoskeag only survived for seven more years before going out of business.

AMOSKEAG BREWE

Andrew C. Wallace,

Proprietor.

—Also Manufacturer of and Dealer

Building Lumber, Boa

Clapboards, Laths,

Etc., Etc.

South Main Stree

'Squog.

An Amoskeag Brewery Advertisement, c. 1877. Located in the Piscataquog Village section of Manchester, known to residents as simply "Squog," this brewery was operated at first by the partnership of Haines and Wallace. However, within a few years, Haines was out and Andrew Wallace was the brewery's sole proprietor. At its peak in 1875, Amoskeag Brewery employed six men and brewed 6,000 barrels of ale a year using 14,000 bushels of barley and 15,000 pounds of hops. As evidenced by this advertisement from a Manchester city directory, Wallace had other business concerns, the most prominent of which was a steam lumbermill.

ANDREW C. WALLACE,

MANUFACTURER OF AND DEALER IN

Building Lumber, Boards, Clapboards,

LATHS, SHINGLES, FENCE PICKETS,

Packing Boxes, Trunk Woods, etc.; also, Wickoff's Patent Water Pipe and Tubing. Framing Schedules Filled, Boards Planed and Matched. Orders received through the Post-office, or at the Steam Mill, Piscataquog, will receive prompt attention.

MANCHESTER, N. H.

AMOSKEAG BREWERY.

PORTER

PALE ALE

AMBER ALE

ANDREW C. WALLACE,

BREWER OF

Amber XX and XXX Ale,

Of superior quality, in barrels, half-barrels, and kegs, Also,

Manufacturer and Dealer in Malt.

Terms Cash.

MANCHESTER, N. H.

AMOSKEAG BREWERY, ANDREW WALLACE ADVERTISEMENTS, C. 1880. The fact that Wallace operated a lumbermill and a brewery together, as demonstrated by these city directory advertisements, is not unusual. Not only was the brewery's cooper able to use wood from Wallace's mill to fashion casks for the ale they produced, but the mechanics that worked at the steam mill were also likely to be quite useful at times in servicing and maintaining the brewery's equipment.

THE TRUE W. JONES BREWING COMPANY, C. 1901. Coyly entitled *The Invitation*, this portrait of a woman enjoying a glass of True Jones brew adorns a tin serving tray. Just as today, brewers of the past used a wide variety of tools to advertise their product from the coasters, bottle openers, and serving trays used in local saloons to decorative lithograph prints and calendars. (Courtesy Rus Hammer.)

TRUE W. JONES, President. M. J. CONNOR, Treasurer

TRUE W. JONES BREWING CO.

=== BREWERS OF ===

Jones' Ales and Porter

HANCOCK STREET,

Manchester, = = = New Hampshire.

A TRUE JONES ADVERTISEMENT, 1894. Like his well-known brother Frank Jones, True Jones was best known as an ale maker. His company ruled the brewing scene in Manchester from its inception in 1894 and, despite his early death in 1899, continued until its demise due to state Prohibition in 1917. Manchester did not see another brewery until 77 years later, when the Stark Mill Brewery began operations in 1994.

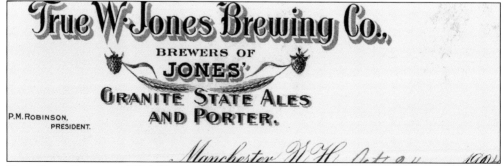

TRUE JONES BILLHEAD, 1904. Despite the early death of True W. Jones on October 2, 1899, at age 56, the brewery that bore his name continued in business for another 18 years. This decorative billhead, dated October 1904, highlights the hops and grains used in the brewing process, most of which were purchased by Jones from sources in Canada. (Courtesy Rus Hammer.)

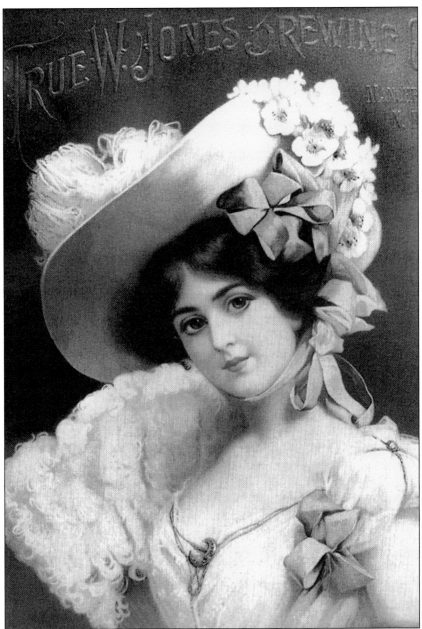

A True W. Jones Brewing Company Advertisement, c. 1890. The depiction of attractive young women in American brewery advertising has a long history, dating from the mid-19th century, and New Hampshire brewers were no exception when it came to the use of such images. This attractive advertisement for the True W. Jones Brewing Company is typical for its day, showing a young woman of the Victorian era with all her finery. By using such images, brewers like Jones were trying to portray their brews, long the drink of choice among working-class men, as an eminently suitable drink for both men and women of a more refined and elevated status within society. Such advertisements were meant to appeal to women, in stark contrast to today's beer advertisements that use blatant female sexuality to attract male consumers. (Courtesy Rus Hammer.)

JONES BEER BOTTLES, C. 1900–1910. Prior to operating his brewery, True Jones served as brewmaster for the Bay State Brewery in South Boston, owned by his brother Frank. Below are bottles for Jones's well-known Granite State porter and ale, the former being a type of brew his brother Frank did not produce. Seen in the image to the left is a bottle for Jones' Lager Beer. The fact that this bottle bears the Jones name and Granite State trademark name, as well as the fact that it is a lager beer identifies it as a True Jones product. However, the designation of Portsmouth on the bottle likely indicates that it was brewed at the Frank Jones Brewery. Given the close relation between the two brothers, the sharing of brewing facilities at one time or another, though undocumented, would not have been unusual. (Left and below, courtesy Rus Hammer.)

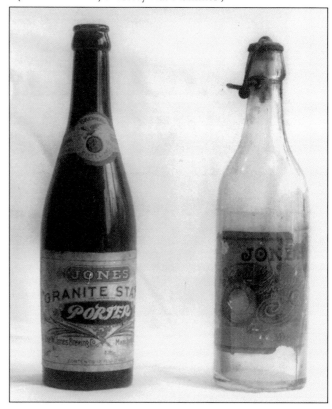

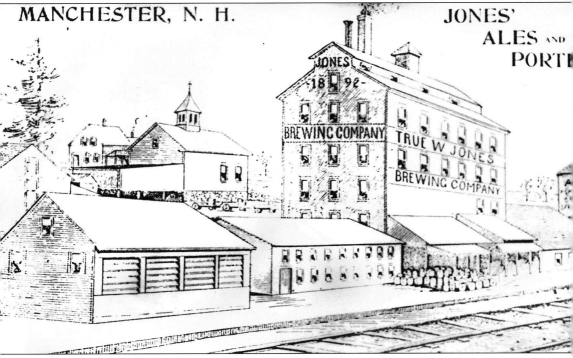

THE TRUE W. JONES BREWING COMPANY. This drawing of the True W. Jones Brewing Company is undated. The date of 1892 on the building may indicate an incorporation date, as brew by Jones did not appear until 1894. True Jones followed in his brother's footsteps and ran a stove business that ultimately went bankrupt. He later worked as a conductor on his brother's Portsmouth and Dover Railroad and probably the Frank Jones Brewery until becoming brewmaster at the Bay State Brewery. There is little doubt that Frank Jones set up his brother to be the king of brewers in Manchester, possibly using the proceeds from the sale of his own brewery to the English in 1888 to help him acquire the old Carney and Lynch Brewery. True Jones was more educated than his brother, receiving schooling at Hampton Academy, but he was always in frail health. He was physically exempted from fighting in the Civil War and died in 1899 at a relatively young age. (Courtesy Rus Hammer.)

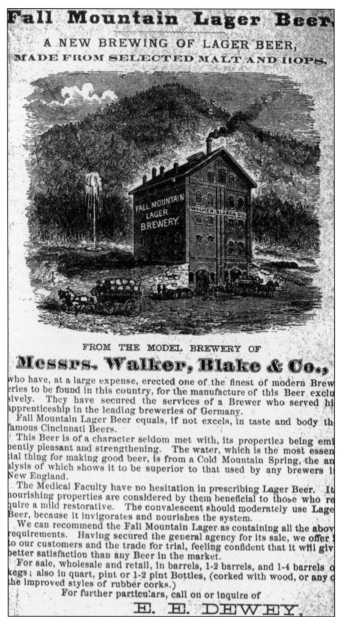

Fall Mountain Lager Beer,

A NEW BREWING OF LAGER BEER,
MADE FROM SELECTED MALT AND HOPS.

FROM THE MODEL BREWERY OF

Messrs. Walker, Blake & Co.,

who have, at a large expense, erected one of the finest of modern Brew
eries to be found in this country, for the manufacture of this Beer exclu
sively. They have secured the services of a Brewer who served hi
apprenticeship in the leading breweries of Germany.

Fall Mountain Lager Beer equals, if not excels, in taste and body th
famous Cincinnati Beers.

This Beer is of a character seldom met with, its properties being emi
nently pleasant and strengthening. The water, which is the most essen
tial thing for making good beer, is from a Cold Mountain Spring, the an
alysis of which shows it to be superior to that used by any brewers i
New England.

The Medical Faculty have no hesitation in prescribing Lager Beer. It
nourishing properties are considered by them beneficial to those who re
quire a mild restorative. The convalescent should moderately use Lage
Beer, because it invigorates and nourishes the system.

We can recommend the Fall Mountain Lager as containing all the abov
requirements. Having secured the general agency for its sale, we offer
to our customers and the trade for trial, feeling confident that it will giv
better satisfaction than any Beer in the market.

For sale, wholesale and retail, in barrels, 1-2 barrels, and 1-4 barrels o
kegs; also in quart, pint or 1-2 pint Bottles, (corked with wood, or any o
the improved styles of rubber corks.)

For further particulars, call on or inquire of

E. H. DEWEY.

FALL MOUNTAIN LAGER BREWERY, 1877. This advertisement appeared in the Keene city directory for 1877, promoting the new brewery at nearby Walpole, New Hampshire. The brewery was built in the spring of 1877 at a cost of $56,000 and was modeled after a prototype shown at the Centennial Exhibition in Philadelphia. Called the first of its type in the country, it stood five stories high, was made of brick, and measured 60 by 42 feet in size. Its founders were Alvah Walker of Boston and Warren Walker and Charles Blake of Bellows Falls, Vermont. The brewery, one of the most modern in the country, had as its brewmaster, a German immigrant named Charles Keller. Within a few years of its founding, by 1880, the brewery employed 11 workers and annually produced 15,000 barrels of its popular lager beer. Though destroyed by fire on May 5, 1882, the brewery was soon rebuilt, being ideally situated due to its location near the Cold River.

A MOUNTAIN SPRING BREWING COMPANY CALENDAR, c. 1893. The brewery at Cold River in Walpole went through many name changes during its 31-year history. This calendar reflects the third name for the brewery, a short-lived one that lasted from 1893 to 1895. Note the designation of Bellows Falls, Vermont. Through the years, this company's headquarters were often in Vermont. However, the brewery itself was always located in New Hampshire. (Courtesy Rus Hammer.)

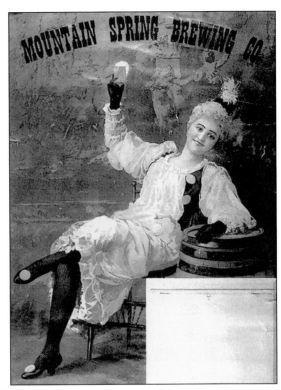

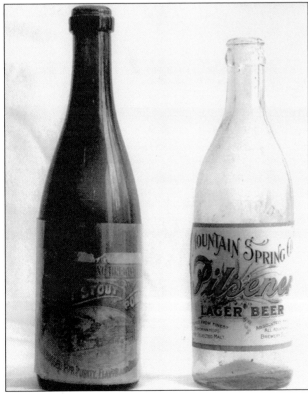

MOUNTAIN SPRING BOTTLES, c. 1890s. These bottles show the varieties of brew produced by Mountain Spring. To the left is their Brown Stout Porter, which shows a picture of the brewery on its label. To the right is the Pilsener Lager Beer, for which they are well known. It is interesting to note that the refrigerator for this brewery originally contained 600 tons of ice and had a capacity of 2,000 barrels. (Courtesy Rus Hammer.)

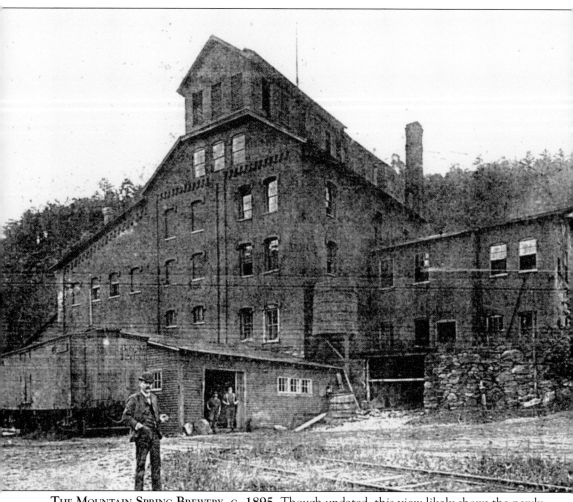

THE MOUNTAIN SPRING BREWERY, C. 1895. Though undated, this view likely shows the newly rebuilt Mountain Spring Brewery after its recovery from a fire in 1882. Compare this view to the previous illustration for the Fall Mountain Brewery, and note that the original center building is largely the same, except for the addition of a sixth story. Note also how the building has expanded from the original on either side and the addition of a Boston and Maine Railroad siding that enabled the brewery to ship its product by rail to other parts of the state and beyond. The man in the front, though unidentified, is probably the owner, while several brewery workers can be seen in the doorway of the storage shed next to the boxcar. At one time, the brewery annually consumed 3,700 tons of ice and 40,000 pounds of malt. (Courtesy the Rockingham Free Public Library, Bellows Falls, Vermont.)

NEW MOUNTAIN SPRING BOTTLES. From 1895 to 1902, the brewery in Walpole was reorganized as the New Mountain Spring Brewing Company. Their Cruiser brand of beer was named during the Spanish-American War era, and the label pictures a navy cruiser. Note that the beer on the left was bottled in Boston, while their Private Club Lager was a steam lager beer that was uncommon in this area. (Courtesy Rus Hammer.)

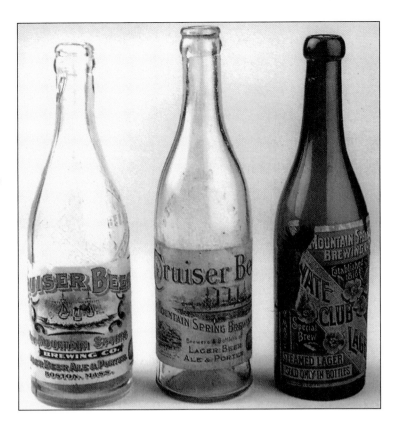

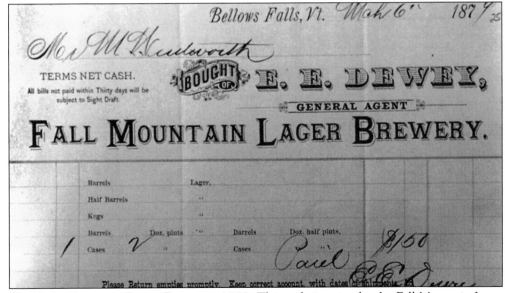

THE FALL MOUNTAIN LAGER BREWERY, 1879. This early invoice for the Fall Mountain Lager Brewery demonstrates just how inexpensive beer really was. For a total of two dozen pints, the customer had to pay only $1.50. The agent on this bill, E. E. Dewey, was at one time a part owner of the brewery. (Courtesy Rus Hammer.)

CRESCENT BREWING COMPANY BILLHEAD, C. 1901. The name on this billhead was the sixth name that the brewery at Cold River in Walpole used. This version of the brewery was a short-lived one, lasting from 1900 to 1902. Though this brewery boasted a quite large yearly capacity, it is unknown how much beer and ale they actually produced. Artifacts from this short-lived concern are rare. (Courtesy Rus Hammer.)

A MANILLA BREWING COMPANY STOCK CERTIFICATE, 1904. The Manilla Brewing Company was the eighth and final incarnation of the old brewery at Walpole. It incorporated in 1904, taking over the plant from the Vetterman Brewing Company. Financed by sinking fund gold bonds, it is doubtful if any of its investors made a profit, as the brewery went out of business for good just three years later. (Courtesy Rus Hammer.)

A Manilla Brewing Company Advertisement, 1905. Despite its short-lived success, the Manilla Brewing Company did quite a bit of advertising to help sell its beers. The German influence on this brewery is seen in its Old German and Wurtzburger Lager brands. Once the brewery was gone for good in 1907, the old building housed the Whitcomb Manufacturing Company during World War I, which produced gunpowder with a 60-man crew. (Courtesy the Rockingham Free Library.)

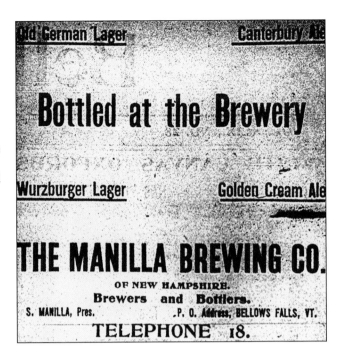

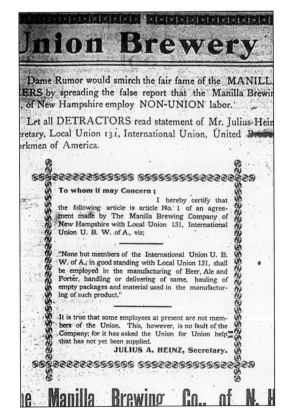

A Manilla Brewing Company Advertisement, 1905. Brewery workers were often paid higher than those in other factories, no doubt due to the efforts of the United Brewery Workmen of America. Issues were usually put to the test in large urban centers like Philadelphia and Cincinnati. As evidenced by this advertisement, rural New Hampshire and Vermont had few brewery workers and even fewer that belonged to the local union. (Courtesy the Rockingham Free Library.)

THE NUTFIELD BREWING COMPANY. This craft brewery was established in Derry in 1995 with Alan Pugsley as brewmaster. To the lower right is the label for one of its ales. The brick kettle brewing system that Nutfield used (similar to the one shown here) was designed by Peter Austin of England. At its height, the brewery produced about 7,700 barrels of brew before ceasing operations in 2003. (Courtesy Alan Pugsley.)

THE CASTLE SPRINGS BREWERY. This short-lived brewery was operated by the Castle Springs Water Company from their location near the site of the historic Castle in the Clouds mansion in Moultonborough. This concern operated from 1996 to c. 2001 with Richard Young as brewmaster, producing Lucknow brand ales. In 1997, two of their brews, the Lucknow India Pale and Lucknow American Wheat, won awards at the Great American Brew Fest. (Courtesy John Phillips.)

Six

GETTING BEER AND
ALE TO THE CONSUMER

Once a brewer crafted his product, he had the challenge of getting his brew into the hands or, better yet, mugs of the public. To do so required the employment of marketing methods that have changed little to this day. As the brewing industry in New Hampshire grew and competition developed, word-of-mouth advertising was no longer enough. The sign maker's art and print media advertising became increasingly important, usually in the form of simple newspaper or city directory advertisements. To go along with this, brewers also had to expand their markets by finding agents (distributors) to sell their product, with the agent making his own profit as a middleman. This enabled brewers like Frank Jones to sell their brew outside of the city in which it was made. In time, this system developed in New Hampshire to the point where brewers could only sell their product through such middlemen, and they were restricted by law from selling directly to the public. It has only been in the last several years that this restriction has been lifted. Brewers in the past usually shipped their beer in casks to its final destination, where it was then bottled by a local bottler. Brew was only available either on draft or in bottles. By the time the steel can came into use in 1935, the brewing industry in New Hampshire was dying. Because of this and the huge expense involved to re-tool from bottles to cans, no beer cans for the state's early brewers were ever produced.

CATCH HIM BOYS!

Copyrighted *Bufford Boston*

dams' Ale House, "Jack Adams" Propriet

— WHOLESALE AGENCY FOR —

RANK JONES' ALES AND SCHLITZ' MILWAUKEE BEE

OPP. PHENIX HOTEL. CONCORD. N. H.

AN ADVERTISING CARD, C. 1890. Note that the Adams alehouse in the state capital of Concord served not only New Hampshire's best-known ale but also the famous Schlitz brand beer from far-off Milwaukee, Wisconsin. Illustrated cards such as this were handed out by local saloons and alehouses to advertise their wares and show just how far across the country some brewers extended their distribution. (Courtesy Rus Hammer.)

Locke's Oyster House,

Post-office Block, Great Falls, N. H.

CHARLES A. LOCKE,

Proprietor.

OYSTERS

at Wholesale and Retail. Choice
CIGARS, ALES AND WINES.

Sole Agent for H. Eldredge & Son's
Ale in Great Falls, Dover & vicinity

A LOCKE'S OYSTER HOUSE ADVERTISEMENT, C. 1875. Just like today, agents for a brewing company were usually given exclusive rights to a particular geographical area. In this case, Charles Locke was the agent for Portsmouth's Eldredge Brewery in Great Falls (Somersworth), Dover, and surrounding towns. There is no doubt that he also served Eldredge's ale on draft at his oyster house. (Courtesy the Somersworth Historical Society Museum.)

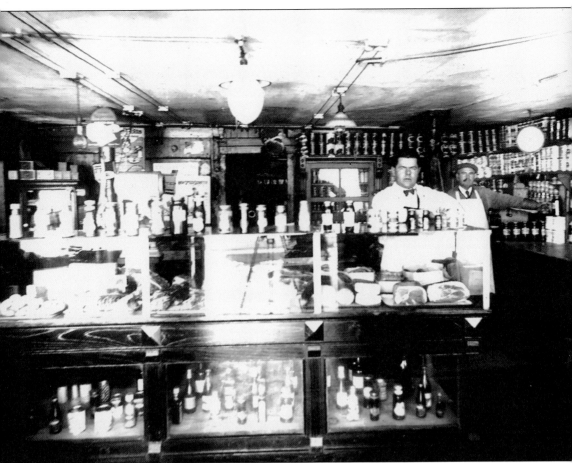

LaBonte's Market, Somersworth. Local stores similar to this well-known market in Somersworth often sold beer and ale to their customers, along with a wide variety of other beverages. Note the lower-level glass cases with bottles of beverages on display. To the right in the front is Wilfred LaBonte, and behind him is his father and founder, Joseph LaBonte. The market first opened for business in 1903 and was located in the LeHoullier Building. Wilfred's son, Dick LaBonte, recalls that there were always rumors about some markets in town that sold beer and ale during the days of Prohibition illicitly out of their back door to willing customers, but LaBonte's Market was not one of them. This Somersworth market operated until a fire forced its closure in 1945. (Courtesy the LaBonte family.)

An Advertising Card, c. 1900. Harrington was a well-known dealer in all types of beverages in Manchester during the late 19th and early 20th centuries. From high-class brandy to soda of all flavors, this company sold them all. Note that Harrington's bottled not only the New Hampshire–produced Eldredge's Ale but also lager beer from far-off Milwaukee. It is unknown which of these was the better seller. (Courtesy Rus Hammer.)

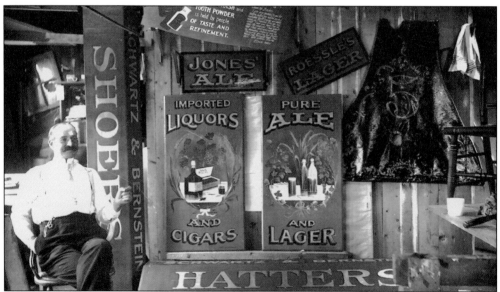

A Sign Maker's Shop, c. 1900. This unusual view shows the finished products of a local sign maker. Note the signs for Jones' Ale and Roessle's Lager at the center. The Jones' Ale sign may have been made to advertise the brew for Manchester's True W. Jones Brewery or maybe Frank Jones's brewery in Portsmouth, but the location of this shop is unknown. Note the workbench and sawhorse to the right. (Courtesy Rus Hammer.)

AN ALBANY STEAM BOTTLING ADVERTISEMENT, 1894. New Hampshire was not only the home of many local bottlers but also larger bottling companies from outside that maintained local bottling works. This city directory advertisement shows that Manchester, for a short time only, was a branch location for an Albany, New York, concern that bottled brew from the Hinckel Brewing Company, likely also based in New York.

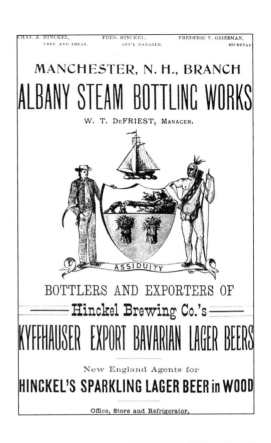

A CHARLES E. BOYNTON ADVERTISEMENT, C. 1879. Local bottling concerns, such as this one that started in 1873, were largely producers of soda and related beverages, such as ginger ale and birch beer. However, they were also important in the brewing industry, as they not only bottled beer for local brewers but also brewed their own quantities of small beer, which was often designated for family use. (Courtesy the Portsmouth Public Library.)

L. A. HUNTLEY,

Dealer in and Bottler of

Moerlein's Cincinnat

AND THE CELEBRATED

*Families and Hotels supplied by the Case o
reasonable terms.*

AN L. A. HUNTLEY ADVERTISEMENT, 1884. While many New Hampshire bottlers were distributors of locally produced beer and ales, this was not always the case, as demonstrated by this city directory advertisement. This Keene city bottler dealt strictly with imports, such as the popular lager and brew from the large Christian Moerlein Brewery in Ohio.

B. McDERMOTT & CO.

DEALERS IN
Foreign and Domestic
Liquors, Wines, and Porte

DEPOT ST., CONCORD, N. H.

Agents for Eldridge's
Pale, Amber, Cream, and Stock Ale
Put up in Barrels, Half-Barrels, and Butts.

ALL ORDERS FAITHFULLY AND PROMPTLY ATTENDED TO.

A McDERMOTT AND COMPANY ADVERTISEMENT, 1869. This dealer in Concord was a wholesale distributor of liquor, wine, and beer in the city for many years, and he was the sole agent for the ales of the Eldredge Brewery in Portsmouth.

ΤΕΑΜ BOTTLING WORKS

J. R. CHAMPLIN. Bottler,

MANUFACTURER OF ALL KINDS OF

Carbonated Beverages

Flavoring Extracts and Colors.

WHOLESALE DEALER IN

Lager Beer, Porter, Ale, and Cider.

Fountains charged with plain Soda Water, Mineral Spri
Water, and the various kinds of Root Beer. Siphon Bot
filled with Mineral Water or Plain Soda. Champlin's Stand
Ginger Ale, White Jamaica Ginger Ale, White Birch Beer
some of our specialties.

General Office, 36 Court St., Works in Rear, 16 Court Sq

LACONIA, N. H.

N. E. Telephone Call, 47-2. Citizens,

SELTZER. CARBONIC ACID WATER

A CHAMPLIN BOTTLING WORKS ADVERTISEMENT, 1882. John R. Champlin operated one of the few bottling works found in the northern part of New Hampshire, and he may have even brewed his own ale for a short time. He opened his bottling plant in Laconia at least as early as 1872, was still in operation as late as 1906, and seems to have been quite the Renaissance man. Not only did he operate his bottling works, bottling lager beer from Cincinnati and Milwaukee, but he also designed and manufactured iron hitching posts and telescopes from a machine shop on Canal Court. In addition to being a manufacturer, Champlin was an avid astronomer, as evidenced by an observatory he built on Jewett Hill in Laconia. At the height of his prosperity, John Champlin's business extended over a large part of northern New Hampshire.

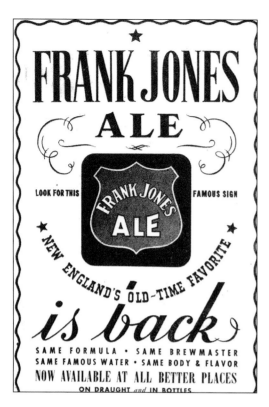

A Frank Jones Advertisement, c. 1937. Following Prohibition, only the Eldredge Brewery in Portsmouth survived, but by 1937, it had been taken over by a group that included former Portsmouth mayors Albert Hislop and Andrew Jarvis. They brewed Jones's ale at the old Eldredge Brewery and piped it over to the old Jones Brewery refrigeration plant. The famous Jones name continued in the city before its final demise in 1950. (Courtesy Rus Hammer.)

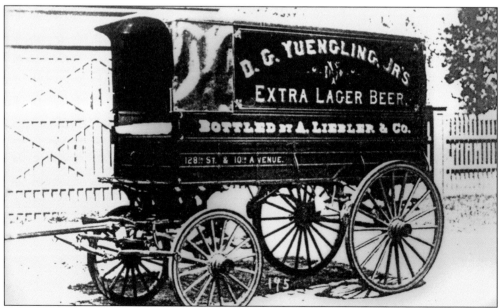

An Abbot-Downing Beer Coach. One of the more unusual aspects of the beer business in New Hampshire is the role played by the Abbot-Downing Coach Company of Concord. Well known for the famous Concord coaches that helped tame the West, they were also major producers of various beer-delivery vehicles for many brewers on the East Coast, including the Yuengling Brewery of Philadelphia. (Courtesy the New Hampshire Historical Society.)

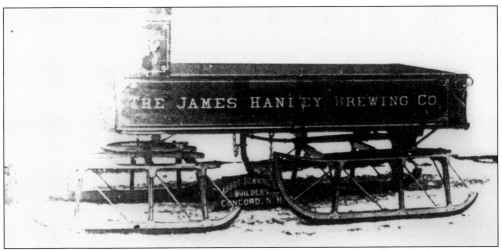

AN ABBOT-DOWNING BEER WAGON. Beer was brewed year-round, and methods to get it to market in every season were found. This beer wagon with runners was built for the James Hanley Brewing Company, based outside New Hampshire. Though no examples of this type survive for New Hampshire, this company is known to have produced other types of wagons for brewers like Frank Jones. (Courtesy the New Hampshire Historical Society.)

NELSON LANE,

DEALER IN DRAUGHT AND BOTTLED

PORTER, ALE, CIDER & BEER,

Fountain and Bottled Soda,

Elderberry, Blackberry, Currant and

NATIVE GRAPE WINES.

ALSO,

Bay Rum, Horse Radish, Pickles,

KETCHUPS, Etc.

SODA FOUNTAINS CHARGED TO ORDER.

A NELSON LANE ADVERTISEMENT, 1886. This Nashua dealer bottled not only beer and ale but also a wide variety of other beverages and condiments, as evidenced by this city directory advertisement. Pictured in Lane's advertisement is the carbon dioxide system that was used to charge soda fountains. Despite its size, Nashua is not known to have had any major brewers, likely due to its proximity to those in Massachusetts.

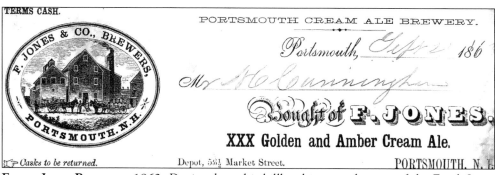

FRANK JONES BILLHEAD, 1863. Depicted on this billhead is an early view of the Frank Jones Brewery. Note the reminder at the bottom left: "Casks to be returned." Empty casks were stored in a shed at the brewery for later reuse, and it was common wisdom that if the cask shed was full, more often than not, a brewer would not be long in business. (Courtesy Rus Hammer.)

BEER SALESMEN, C. 1945. This view shows what appears to be a gathering of salesmen from the Bellavance Beverage Company from Nashua. Note the metal kegs of beer, probably empties, used as stools in the foreground. This company is one of the oldest beer distributors (formerly called agents) still in operation in the state today. (Courtesy the Bellavance family.)

THE JUNIOR TEMPERANCE CLUB, C. 1900. While beer was touted for family use by brewers in the early 20th century, temperance clubs such as this Somersworth group were pushing hard for Prohibition. At first their efforts focused on heavy drink such as whiskey and rum, but in the end a ban was won, at least temporarily, on all alcoholic beverages in the state from 1917 to 1933. (Courtesy the Somersworth Historical Society Museum.)

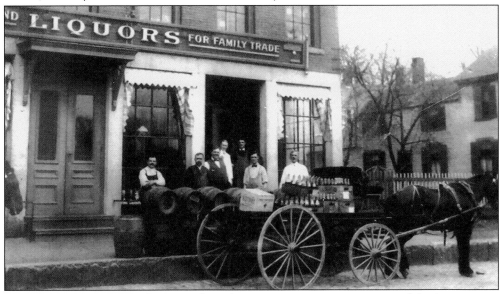

BEER DELIVERY, C. 1890. Scenes such as this one were common in many of the larger towns or cities when the horse and wagon were used to deliver beer and similar beverages. This photograph was taken in Nashua and depicts the operations of the Bellavance Beverage Company in its early days. Soon enough, motor vehicles took the place of the horse and wagon. (Courtesy the Bellavance family.)

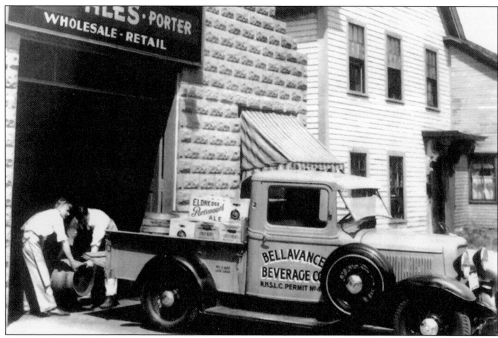

BELLAVANCE BEVERAGE DELIVERY TRUCKS, C. 1933 AND TODAY. With the invention of the automobile and truck, the days of the horse-drawn delivery wagon were soon a thing of the past, gaining only a slight revival during the gasoline-rationed war years of World War II. Seen above is a Bellavance Beverage truck just after the end of Prohibition. Note the case of Eldredge Portsmouth Ale in the top of the bed and the company's New Hampshire State Liquor Commission (NHSLC) permit number on the door. Below is the modern delivery fleet of the Bellavance Beverage Company, adorned with the name of the major beer that they distribute today. (Above and below, courtesy the Bellavance family.)

Seven

New Hampshire's Current Breweries

When the last New Hampshire brewery closed its doors in 1950, the state went for 20 years without a brewery. During this time, much changed in America's brewing industry. Slowly but surely, consolidation was taking place, and many local breweries all across the country were being taken over by larger breweries such as Anheuser-Busch, the Miller Brewing Company, and several others. Also during this time, the quality of mass-produced American beers became watered down and lost their regional distinction, in most cases, in everything but their name.

New Hampshire finally regained a brewery within its borders in 1970, when Anheuser-Busch opened a plant in Merrimack in 1970. The largest brewery ever in the state, it currently produces about three million barrels of beer yearly and is the smallest of the company's 13 regional breweries.

The state's second-largest brewery today is the Red Hook Ale Brewery. Based in Seattle, Washington, this brewer opened an East Coast brewery in Portsmouth in 1996, and its estimated yearly output is about 75,000 barrels. The next largest brewery is the Smuttynose Brewing Company of Portsmouth. Started by brewer Peter Egelston in 1994 using equipment from the defunct Frank Jones Brewing Company (which operated for just a year from 1991 to 1992), the brewery was projected to produce nearly 10,000 barrels of beer and ale in 2004. Rounding out the state's other breweries are two located in the White Mountains, the Tuckerman Brewing Company of Conway, begun in 1998, and the Franconia Notch Brewing Company of Littleton, founded in 1996.

THE FRANCONIA NOTCH BREWING COMPANY. Started in 1996 by brewers John Wolfenberger and Al Pilgrim, this brewery in Littleton is the state's smallest and is now essentially a one-man operation. However, this did not prevent it from garnering the most votes for best beer at the Gunstock Brewfest in 1997 and 1999. It was also named the Best of New Hampshire in 2003 for its Grail Pale Ale (seen below). A former home brewer, Wolfenberger has a background in chemical engineering from Ohio State, and his brew reached the local market in 1997 with a lot of help from his friends. Successful smaller breweries like this one are now economically viable due to recent changes in New Hampshire law that allows them to distribute their own brew. Among those who fought for this change was Wolfenberger. (Courtesy John Wolfenberger.)

FRANCONIA NOTCH EQUIPMENT. This is some of the primary equipment used by the Franconia Notch Brewery. The beautiful hot liquor back tank on the right is made of bird's-eye maple and was originally used in the production of maple syrup before its conversion. To the left is the brick-lined brew kettle, the bricks serving as an insulator. Brewers from an earlier day would recognize these items. (Courtesy John Wolfenberger.)

THE FRANCONIA NOTCH BREWERY. Here, finished ale is being siphoned from wood casks into other containers, perhaps kegs or growlers (64-ounce glass jugs), prior to their final sale. At the rear in the upper corner are bags of malt or hops used in the production process. Many smaller breweries like this one have returned to the old ways of producing their brew, resulting in a truly handcrafted product. (Courtesy John Wolfenberger.)

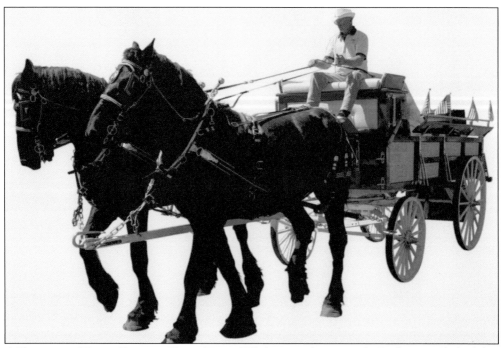

A Franconia Notch Brewery Horse Team. While not as famous as the Budweiser Clydesdales, the Franconia Notch Brewing Company has, on occasion, trotted out its own set of draft horses to pull its brewery wagon. (Courtesy John Wolfenberger.)

Tuckerman Brewing Company Equipment. This is a view of the company's 20-barrel brewing system. In front at the left is the mash tun, where a raw mix known as grist is mixed with hot water to create the sweet, sticky liquid called wort. From here it goes to the brew kettle, which is barely visible at the left rear. (Courtesy Tuckerman Brewing.)

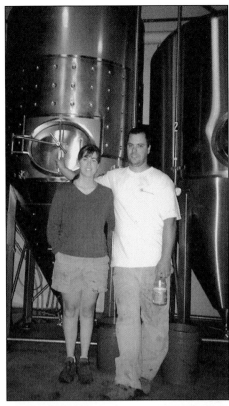

THE TUCKERMAN BREWING COMPANY. Located on Hobbs Street in Conway, this brewery got its start in January 1998. It was founded by Kirsten Neves, a native of Milwaukee, and Nik Stanchu, a native of Goffstown, New Hampshire. Nik has a background in physics and chemistry and previously worked at the Los Alamos National Laboratory in New Mexico. While there, the couple helped out some friends who owned a microbrewery and were thus inspired to open one of their own. Their flagship brew is an American-style pale ale (seen below), each batch requiring about three and a half weeks from start to finish. In 2003, the company produced and sold about 50,000 cases, and with current expansion, this will increase to 80,000 cases. In 2004, they were voted the Best of New Hampshire in the beer category. (Courtesy Tuckerman Brewing.)

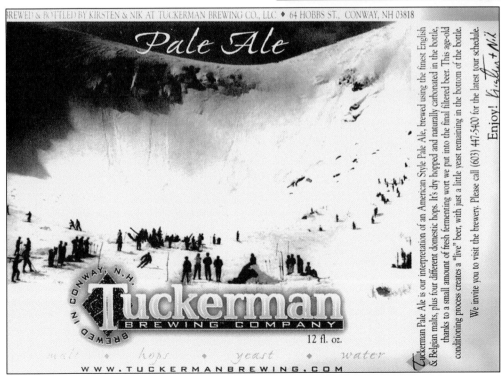

TUCKERMAN'S BOTTLING PROCESS. Here is shown the bottling process for Tuckerman Pale Ale. The nearly finished product is transferred to the bottling tank, also known as the brite beer tank, and is subsequently bottled for six-packs, as is the case here, or racked into kegs. (Courtesy Tuckerman Brewing.)

SMUTTYNOSE BREWING COMPANY EQUIPMENT. In the background of this view are the giant and colorfully decorated holding tanks for the finished product of this Portsmouth brewery. In the foreground is a washing station. Many tanks such as these were converted from other uses, often from the dairy industry, for use in a modern-day craft brewery. (Courtesy Smuttynose Brewing.)

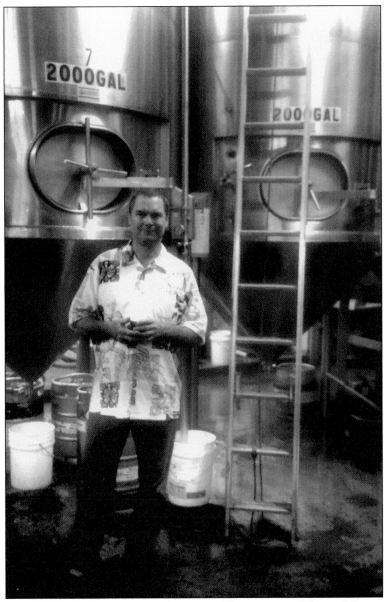

PETER EGELSTON, SMUTTYNOSE BREWING COMPANY. This pioneer of the craft-brewing industry in the state is a native of California who attended college in New York. He first taught English to non-English–speaking children in the inner city before cofounding the first brewpub ever in Massachusetts, in Northampton. While looking to expand, he looked northward, away from the regulatory nightmare of the Bay State, to New Hampshire. Peter subsequently owned and operated the first brewpub in the state, the Portsmouth Brewery. As Peter recalls, when the equipment for the recently defunct Frank Jones microbrewery came up for sale in 1993, his company was "at a fork in the road," and he took the turn that led to the establishment of the Smuttynose Brewing Company. Through bad times and good, his hard work and that of his brewers is now paying off. Smuttynose has been the state's largest craft brewer since 1998 and is currently ranked as the 63rd largest commercial brewery in the country. They expected to produce nearly 10,000 barrels of brew in 2004. (Courtesy Smuttynose Brewing.)

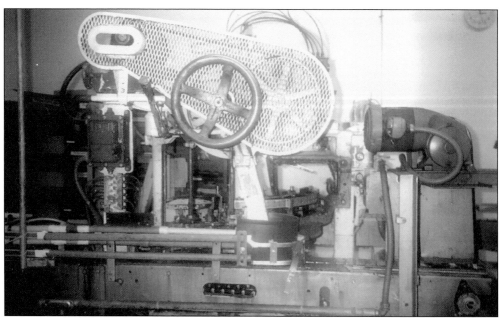

THE SMUTTYNOSE BREWING COMPANY. The equipment for small breweries like Smuttynose is often a combination of the old, the not as old, and the new. The labeling machine shown above dates from *c.* 1950 but was patented *c.* 1905. A machine much like this one, with a capacity of labeling 70 bottles per hour, was possibly used by the original Frank Jones Brewery prior to Prohibition. Below is the bottle-filling station. This machinery, much more modern technology, is capable of filling 200 bottles per hour. Because of the difference in capabilities for these machines, the brewery's bottling line must be slowed to accommodate the lesser capacity. With future plans in the works to expand to bigger and better quarters in the nearby Newmarket mill complex, the labeling machine above may soon be replaced. (Courtesy Smuttynose Brewing.)

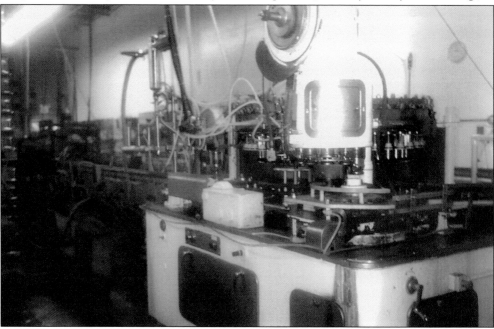

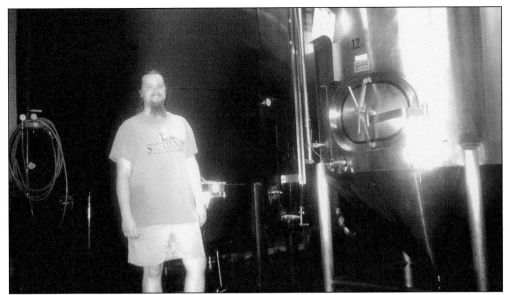

GREG BLANCHARD, SMUTTYNOSE BREWING COMPANY. Greg Blanchard is a native of this state who gained a degree at the University of New Hampshire. He came to Smuttynose in 1998 and is now head brewer. His operations are directed by executive brewer Dave Yarrington, who holds degrees from the University of California–Davis and Colby College. Together with owner Peter Egelston, they help decide what new beers or ales to introduce. (Courtesy Smuttynose Brewing.)

AN EMPTY MASH TUN. Depicted here is a stainless steel mash tun. The motorized rakes at the tank's bottom mix malt and water in the early stages of brewing. Since the brewing equipment for Smuttynose was gained from a variety of sources, whether another brewery, new, or adapted from the dairy industry, their brewers, like many in the craft-beer industry, are jacks of all trades. (Courtesy Smuttynose Brewing.)

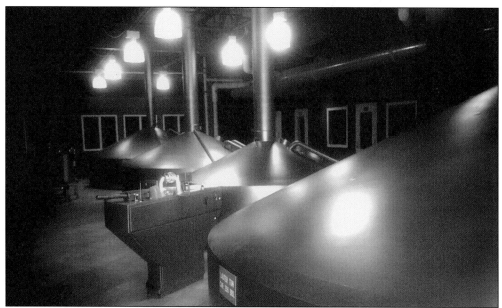

RED HOOK BREWERY BREW KETTLES. This Washington State brewery commissioned its Portsmouth plant in 1996. It currently produces about 75,000 barrels of brew annually and is not yet brewing at full capacity. When full capacity is reached, it will brew as much as the Frank Jones Brewery did, but with only about 35 people doing the work. This room houses the brewery's state-of-the-art brew kettles. (Courtesy Red Hook.)

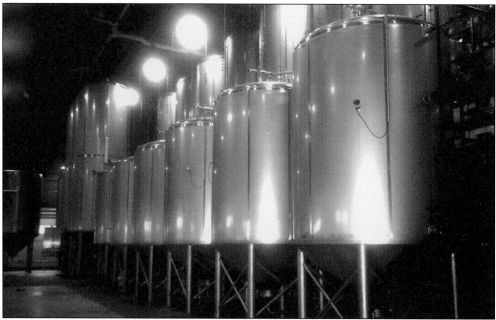

RED HOOK BREWERY FERMENTATION TANKS. Housed in a cavernous building, this bank of giant primary fermentation tanks is where Red Hook ales are aged before being bottled or racked in kegs. These tanks range in size from 2,000- to 4,000-barrel capacities. The Red Hook Brewery in Portsmouth is notable for its high-tech efficiency, and it is one of the most modern breweries on the East Coast. (Courtesy Red Hook.)

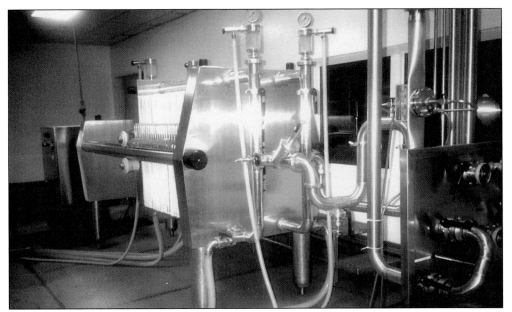

THE RED HOOK BREWERY COLD-FILTER ROOM. One aspect of the Red Hook Brewery that strikes many visitors right away is its cleanliness, something in which brewery personnel take great pride. This piece of equipment cold-filters most of Red Hook's ales before they go through the final bottling process. The amount of beer and ale produced at Portsmouth alone makes this brewery about the 25th largest in the country. (Courtesy Red Hook.)

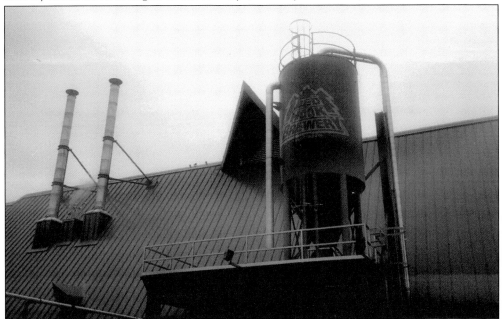

THE RED HOOK EXTERIOR. This outside view shows the distinctive peaked roofline of Red Hook. The large tank with the brewery's name and logo contains the spent grains that are the waste product from the brewing process. Just as in days of old, these grains are released via chute to trucks waiting underneath for subsequent use by local farmers as feed for their livestock. (Courtesy Red Hook.)

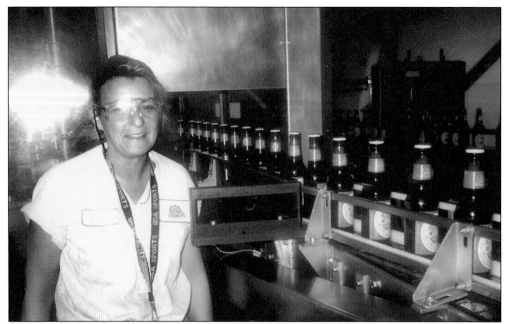

THE RED HOOK BREWERY BOTTLING LINE. The bottling room at Red Hook is one of the most fascinating rooms in the entire brewery. The overhead view (below) shows the center of the high speed line. The bottles are filled at stations to the left and snake through the line to the right, where they are eventually packed into cases for shipment. Note the cardboard cases stacked in the background and the filled case heading up the conveyer belt at the upper left. Above is line supervisor Pam Wayne at the bottling line. Workers here, ever safety-conscious, monitor the line for breakage and quality-control issues. The bottling line runs for three or four days a week, depending on the season, operating from about 6 a.m. to 3 p.m. (Courtesy Red Hook.)

Eight

NEW HAMPSHIRE BREWPUBS AND HOME BREWING

Concurrent with the revival of the brewing industry in New Hampshire has been the revival of the brewpub concept. In the early days, beer and ale were brewed on the premises of local inns and taverns for consumption by their patrons, but by the mid-1800s, this practice fell out of favor. With the rise of the craft-brewing industry in the early 1980s, it was just a matter of time before such an idea would be brought back to New Hampshire. When Peter Egelston's Portsmouth Brewery opened for business in 1991, it made history as the first brewpub in the state. It has been a success right from the start. Since then, a number of brewpubs have followed. Moat Mountain brewer Will Gilson states, "The brewpub movement is now going through a second Renaissance, with less mistakes being made and less places failing." In the beginning, well before cautious New Hampshire became involved, many brewpubs were opened by people without experience either in restaurant management or brewing. Today, there are nine brewpubs operating in the state, many of which have brewing operations conducted by some of the most experienced and respected brewmasters in New England. While the brewers of yesteryear were usually businessmen first, the brewers of today are a different and, admittedly, eclectic group. Not only are they businessman, but they are also part scientist and part artist, crafting beer by hand using modern knowledge and equipment while following the time-honored methods of yesteryear.

Finally, there are the home brewers, whom beer writer Michael Jackson refers to as "the shock troops of the beer revolution." Home brewing has been legalized since 1979, and home brewers of drinking age may brew up to 100 gallons per year for their own use only. While the hobby has waxed and waned in popularity over the years, it has been the pride of crafting one's own beer by hand that has kept it going. Indeed, one might say that home brewers have brought brewing and its history full circle. Not only have they returned brewing to its original place in the home, where it all began in pre-Colonial days, but also by their influence and individual efforts they have founded the craft breweries and brewpub restaurants found in New Hampshire today.

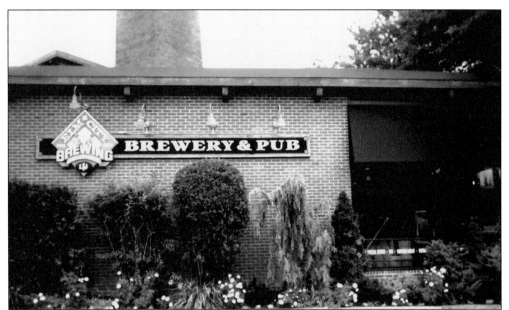

THE ELM CITY BREWING COMPANY. Begun by avid home brewer Debra Rivest, this brewpub opened in Keene in 1995. Head brewer Bill Dunn has completed course work for master brewers at the University of Wisconsin and has worked at several breweries, including Vermont's Long Trail and Broadway Brewing in Colorado. While the pub offers many brews, two favorites are its Keene Kölsch Blonde Ale and Peachy Keene Ale. (Courtesy Elm City.)

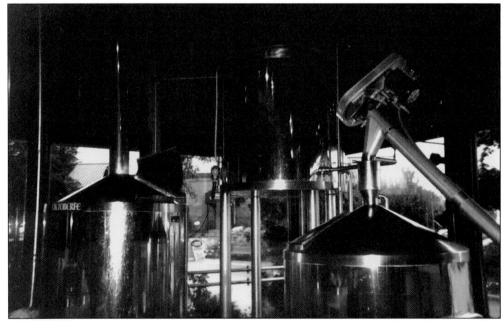

ELM CITY BREWING COMPANY EQUIPMENT. Shown here is the pub's stainless steel seven-barrel direct-fire system, manufactured in Quebec. Note the tank labeled Oktoberfest (left). Elm City offers an IPA, a stout or porter, and several brown ale varieties. They even offer homemade root beer. For those customers wishing to take some brew home, they also offer growlers. (Courtesy Elm City.)

ITALIAN OASIS RESTAURANT AND BREWERY.
This restaurant in Littleton, founded in
1992, has a brewery that is the smallest in
the state. It was begun by John Morello in
1994 and occupies just 77 square feet. In
addition to fine dining, they offer a number
of brews, including an IPA, Golden Amber
Ale, Black Bear Stout, Bee Sting Wheat
Ale, and several other seasonal varieties.
(Courtesy John Morello.)

JOHN MORELLO, ITALIAN OASIS BREWERY.
Like many craft brewers, Morello got his
start as a home brewer. He has received
official brewery training in Montreal and
operates a two-barrel system that produces
about 62 gallons a week. The brewery was
kept purposely small to avoid a high start-
up expense; the cost was less than a new
car. Currently operating at 110 percent
capacity, all of its brew is served strictly
in-house. (Courtesy John Morello.)

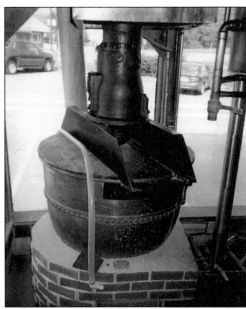

THE SEVEN BARREL BREWERY. This popular brewpub in West Lebanon was founded in 1994 by Nancy Noonan. Head brewer Paul White's ales have won numerous awards, including those at the Yankee Brewers Conference and the Chicago Real Ale Festival. The distinctive brewery, with its equipment available to the public, is shown above with a closeup of its brewing system. (Courtesy the Seven Barrel Brewery.)

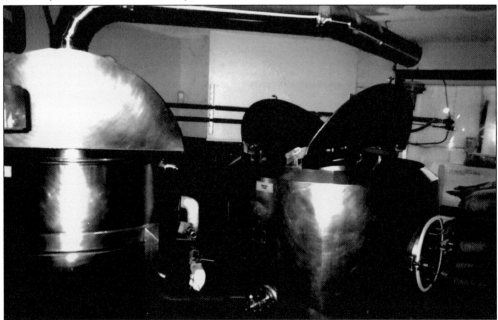

FLYING GOOSE EQUIPMENT. Founded in 1997, the Flying Goose Brewpub operates a seven-barrel system. Head brewer Kevin Kerner took over in 2000, and his creations have since won six medals. Among his 16 ales are the signature Flying Goose Pale Ale, Weetamoo Raspberry Wheat Ale (named after a ship that used to ply the waters of Lake Sunapee), and Loon Island Lighthouse Ale. (Courtesy Kevin Kerner.)

MARTHA'S EXCHANGE RESTAURANT AND BREWING COMPANY. Located in the heart of downtown Nashua, this brewpub was established in 1993. Current head brewer Greg Ouellette, a home brewer since 1992, began his brewing career at Incredibrew, a brew-on-premise facility in Nashua, and he also served an apprenticeship at the now defunct Mill City Brewery in Lowell, Massachusetts. Seen below is the brewery's copper-clad, seven-barrel system. Annual capacity is estimated at about 1,200 barrels. (Courtesy Greg Ouellette.)

THE PORTSMOUTH BREWERY. This historic brewpub was established in 1991, the first in New Hampshire. Distinguished by its old-fashioned frothy mug sign outside (top) and great brew inside, it is truly a Portsmouth landmark. The brewery produces about 800 barrels of brew annually using a custom-made, seven-barrel brewhouse system. During the course of a year, 38 types of beer and ale, including many seasonal and specialty varieties, are offered. Head brewer Tod Mott (below, left) and assistant brewer Mike Luparello are experienced brewers. Mott is known as one of New England's finest brewers. Having worked at the Catamount Brewery in Vermont and Boston's Commonwealth Brewery, he was instrumental in crafting the well-known Harpoon IPA before coming to Portsmouth in 2003. Luparello, new to the brewery in 2002, has previous experience at the Tampa Bay Brewing Company. (Courtesy the Portsmouth Brewery.)

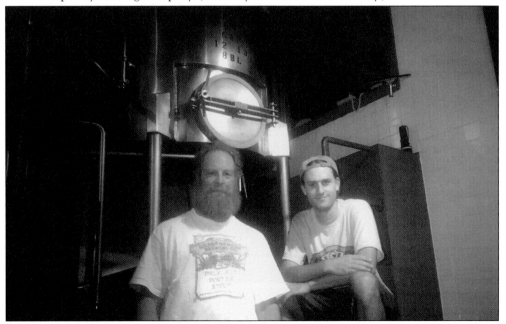

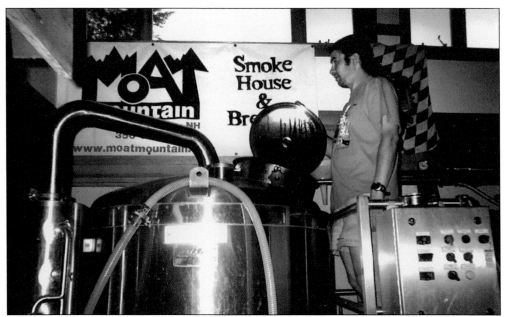

MOAT MOUNTAIN SMOKEHOUSE AND BREWERY. Home brewer Stephen Johnson opened this restaurant in North Conway in 1998, and in 2000 he added his own brewery. Using a seven-barrel steam-fired system, Moat Mountain produces about 600 barrels of brew annually and is available on tap at locations throughout the state. Head brewer Will Gilson has been in charge from the start and has extensive prior experience, including time at the Snake River Brewery in Jackson Hole, Wyoming. Maintaining three different yeasts year-round, Moat produces a wide selection of both ales and lager beers. Their German Wheat beer won best of show at the New Hampshire Craft Brewers Festival in its first months of operation. Above, Gilson is checking out the brew kettle during the cleaning process. Below, he is working at the filtering process. (Courtesy Moat Mountain.)

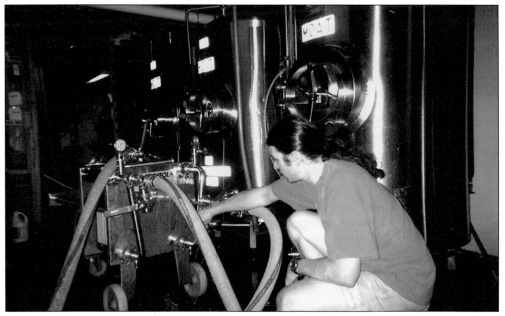

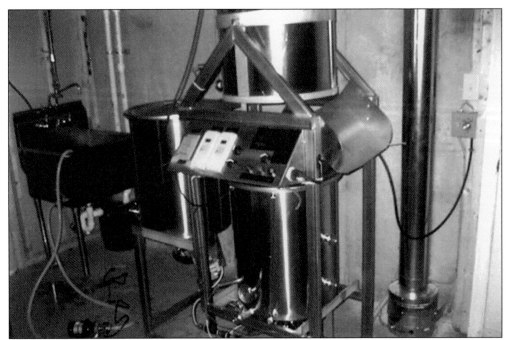

HOME BREWING IN NEW HAMPSHIRE. Since changes in the federal law in 1979, beer aficionados have been able to craft their own beers. This return to the roots of brewing has gained in popularity, and several groups have formed to promote this unique hobby in the state, including Brew Free or Die. This view shows an elaborate home-brewing system, though most are not as advanced as this one. (Courtesy Michael Fairbrother.)

BEAN'S BEST

COFFEETOWN BREW
Brewed and Bottled
in
DEERFIELD, NEW HAMPSHIRE

A HOME-BREWING LABEL. Great pride is taken by home brewers in the beer and ales they produce, as demonstrated by the labels they create to brand their brew for family and friends. With enough experience and know-how, their hand-crafted results are usually as good or better than many commercially produced beers. (Courtesy Angela Bean.)

Appendix

NEW HAMPSHIRE
BREWERS AND BREWERIES

Breweries are listed by city, with dates of operation and known or current head brewers in parenthesis. Taverners are not listed unless their brewing activity has been documented. Brewers that occupied the same physical location in succession are listed as subheadings under the first brewer at that site.

CONCORD
Charles C. Hodgdon, 1836
Edward Taylor, alemaker, 1870

CONWAY
Tuckerman Brewing Company (Kirsten Neves and Nik Stanchu), 1998–present

DOVER
Brew house at Dover Point (Hattevil Nutter?), c. 1640
Cocheco Brewery (Henry Evans), 1864–1869
 Mrs. Henry Evans (Martha Evans), 1869–1870
Daniel Ford, c. 1870–1873
A. Pathe, c. 1875

KEENE
E. G. Harder, 1875–1876
Elm City Brewing Company (Bill Dunn), 1995–present

LACONIA
John Champlin, c. 1870s

LITTLETON
Italian Oasis Brewery (John Morello), 1994–present
Franconia Notch Brewing Company (John Wolfenberger), 1996–present

LONDONDERRY
Nutfield Brewing Company (Alan Pugsley and Scott Watson), 1995–2003

MANCHESTER
Riverious V. Burt, 1854
Michael Prout, 1856–1857
Joseph Wilson, 1860
Haines and Wallace (Andrew Wallace), 1864–1866
 Amoskeag Brewery (Andrew Wallace), 1867–1884
Captain Tucker Brewery, c. 1865
Thomas F. Glancy, c. 1871
Cyrus Dunn, c. 1877–1878
 Carney, Lynch and Company, 1879–1890
 New Hampshire Brewing Company, 1891–1893

True W. Jones Brewing Company, 1894–1917

Stark Mill Brewery (Peter Telge), 1994–1999

Milly's Tavern and Brewery (Peter Telge), 2002–present

MERRIMACK
Anheuser-Busch, 1970–present

MOULTONBOROUGH
Castle Springs Brewery (Richard Young), 1996–2001

NASHUA
Michael O'Grady, c. 1880s

Martha's Exchange Brewery (Greg Ouellette), 1993–present

NEW CASTLE
Samuel Wentworth Tavern, 1669–1678

NEW LONDON
Flying Goose Brew Pub (Kevin Kerner), 1997–present

NORTH CONWAY
Moat Mountain Smokehouse and Brewery (Will Gilson) 2000–present

NORTH WOODSTOCK
Woodstock Inn Brewery (Butch Chase), 1995–present

PORTSMOUTH
Capt. John Mason's brew house, 1635–?

John Webster, c. 1640s, 1651

John Webster Jr., 1652–1668

Henry Sherburne (Glebe Tavern), c. 1700

Brewery at the Creek (Asa Ham?), 1771

Capt. John Bodge, 1801

Michael Martin c.1815

John Swindell, 1856–1858, and at the Creek, 1860–1864

Swindell and Jones (John Swindell and Frank Jones), 1858–1859

Frank Jones Brewery, 1859–1888

Frank Jones Brewing Company, 1889–1917

M. Fisher and Company (Marcellus Fisher Eldredge), 1864–1870

Heman Eldredge and Son Brewery (Marcellus Eldredge), 1870–1874

Eldredge Brewing Company, 1874–1917

Eldredge Brewing Company, 1933–1937

Frank Jones Brewing Company (in old Eldredge plant), 1937–1950

Harris and Mathes Company (Arthur Harris), 1871–1872

Arthur Harris Company, 1873–1876

Portsmouth Brewing Company (Arthur Harris), 1877–1917

Charles E. Boynton, 1873

Portsmouth Brewery Brewpub (Tod Mott), 1991–present

Frank Jones Brewing Company, 1992–1993

Smuttynose Brewing Company (Greg Blanchard and Dave Yarrington), 1994–present

SOMERSWORTH (GREAT FALLS)
Ira T. Daniels, 1870–1884

Hanson and York, 1885–?

STRATHAM
William Pottle Jr. (maltster and brewer), 1770s–?

WALPOLE (COLD RIVER)
Walker, Blake, and Company, 1876–1879

Falls Mountain Lager Company (Walker, Dewey, and Blake), 1879–1886

Bellows Falls Brewing Company, 1886–1893

Mountain Spring Brewing Company, 1893–1895

New Mountain Spring Brewing Company, 1895–1900

Crescent Brewing Company, 1900–1902

New Mountain Spring Brewing Company, 1902–1904

L. J. Vetterman Brewing Company, 1904

Manilla Brewing Company, 1904–1907

WEST LEBANON
Seven Barrel Brewery (Paul White), 1994–present